COLORADO FORTS

COLORADO FORTS

HISTORIC OUTPOSTS ON THE WILD FRONTIER

 Jolie Anderson Gallagher

THE
History
PRESS

Published by The History Press
Charleston, SC 29403
www.historypress.net

First published 2013

Manufactured in the United States

ISBN 978.1.60949.660.9

Library of Congress CIP data applied for.

Notice: The information in this book is true and complete to the best of our knowledge. It is offered without guarantee on the part of the author or The History Press. The author and The History Press disclaim all liability in connection with the use of this book.

CONTENTS

CONTENTS

ACKNOWLEDGEMENTS

For all the dedicated curators, librarians and museum volunteers—thanks so much for assisting me with my research. I also want to thank Carol Turner for reading my drafts and keeping me sane during difficult times. And finally I must acknowledge my marvelously supportive husband, Sean Gallagher. He read my drafts, created maps, took photos and generally held down the fort while I wrote.

INTRODUCTION

Frontier forts played a major role in settling Colorado. These forts included upward of fifty structures built throughout the state—log stockades, trading posts, shelters, stage stations, military installations, temporary camps and cantonments. A few were business establishments, such as Bent's Old Fort in the fur-trading days. Many more were military posts, such as Fort Garland and Fort Lyon, erected after the Mexican-American War. Still others were short-lived stockades and shelters, used for protection against Indians who so desperately tried to push out white settlers.

Although this book uses "fort" to describe a wide variety of posts, it also uses terms for specific types of constructions. A "blockhouse" is a shelter of stacked logs. A "stockade" is similar in construction, except it includes posts fixed upright in the ground. A "picket post" is a group of cabins surrounded by a log barrier, with each log sharpened to a point on the top. A "camp" is a temporary base composed of tents or rude cabins. A "cantonment" is a large military camp, usually for winter quarters but sometimes occupied longer. And a "fort," when used in military terms, is a more permanent base with sturdy buildings.

In addition to describing the fort structures, this book tells the stories of the people who occupied them—the struggles and achievements of early explorers, frontiersmen, fur traders, soldiers and their wives. These early pioneers braved brutal weather and hostile enemies to build not just the forts but also new lives for themselves. Through the years, their trails would become our highways, and their forts would become our city centers, museums, hospitals and schools.

CHRONOLOGY

1807 **Pike's Stockade**. Temporary shelter built by Pike expedition along the Conejos River (four miles east of Sanford). Reconstructed by the Colorado Historical Society and designated a National Historic Landmark.

1819–1821 **Spanish fort** (Fort Sangre de Cristo). Spanish military fort built five miles down the eastern edge of La Veta Pass. The site is on private property.

1820s **Fort Talpa**. Adobe post built by Spanish settlers in the Huerfano Valley for protection against possible Indian attacks.

1820s–1844 **Fort Uncompahgre** (Fort Robidoux). Trading post built by Antoine Robidoux at the confluence of the Gunnison and Uncompahgre Rivers. A replica was reconstructed by the City of Delta in Confluence Park.

1830–1834 **Bent's Picket Post** (Fort William). Trading post built by William Bent along the north side of the Arkansas River, somewhere in Pueblo area. No physical remains.

1832–1834 **Gantt's Picket Post**. Trading post built by John Gantt and Jefferson Blackwell along the Arkansas River, somewhere near Las Animas. No physical remains.

1834–1835 **Fort Cass**. Trading post built by John Gantt and Jefferson Blackwell along the Arkansas River, about six miles below the mouth of Fountain Creek (Pueblo area). No physical remains.

1834–1835 **Fort Convenience**. Temporary trading post operated by Louis Vasquez along Clear Creek (Vasquez Fork) and the South Platte River. No physical remains.

1834–1849 **Bent's Old Fort** (Fort William 2). Trading post built by William Bent, Charles Bent and Ceran St. Vrain along the Arkansas River (near La Junta). Reconstructed by the National Park Service on its original foundation.

1830s–1854 **Fort LeDuc** (Fort Maurice, Buzzard's Roost, El Cuervo). Trading post operated by Maurice LeDuc near the junction of Adobe Creek and Mineral Creek, near Wetmore. No physical remains.

Late 1830s **Milk Fort**. Trading post built by mixed-blood Mexicans and Indians, located a few miles west of Bent's Old Fort. No physical remains.

Late 1830s **Fort Davy Crockett** (Fort Misery). Trading post built by William Craig and Phillip Thompson in Brown's Hole on the Green River and Vermillion Creek. The site is located in the Brown's Park Wildlife Refuge.

1835 **Camp Livingston**. A temporary federal encampment occupied by Colonel Henry Dodge's expedition near Julesburg.

1835–1842 **Fort Vasquez**. Trading post built by Louis Vasquez and Andrew Sublette on the South Platte River (near Platteville). Reconstructed by Colorado Historical Society near its original location.

1837–1838 **Fort Jackson**. Trading post on the South Platte River, between Fort Vasquez and Fort Lupton. Its foundation was uncovered near Ione.

1837–1844 **Fort Lupton** (Fort Lancaster). Trading post built by Lancaster Lupton along the South Platte River (near Fort Lupton). Reconstructed by the South Platte Valley Historical Society a few yards from its original location.

1837–1852 **Fort St. Vrain** (Fort Lookout, Fort George). Trading post built by Bent–St. Vrain partnership on the South Platte River, north of Fort Vasquez. A historical marker is located north of CR-40 on a dirt road.

1840–1841 **Fraeb's post**. Trading post built by Henry Fraeb and Jim Bridger north of Steamboat Springs. No physical remains.

1842–1854 **El Pueblo** (Fort Pueblo, Fort Fisher). Trading post built by former Bent employees on the Arkansas River (in Pueblo). The excavated site is near the El Pueblo History Museum.

1846–1847 **Fort Independence**. Log homes built by Mormon Battalion south of El Pueblo. A historical marker is located at Runyon Field in Pueblo.

1847–1859 **Big Timbers.** Log trading post built by William Bent (near Lamar). No physical remains.

1848 **Frémont's Christmas Camp** (Camp Hope). Winter camp of Frémont's fourth expedition in the San Juan Mountains, about twenty-five miles northwest of Del Norte. Some evidence remains near the Cathedral campground.

1852–1858 **Fort Massachusetts**. Military fort built at base of Mount Blanca, north of Fort Garland. The excavated site is part of a field-training program in archaeology (offered by Adams State University).

1853–1860 **Bent's New Fort** (Fort Fauntleroy). Stone trading post built by William Bent on the bluffs above the Arkansas River, eight miles west of Lamar. The U.S. Army leased the fort as a warehouse and renamed it Fort Fauntleroy. The foundation is on private property.

1858–1883 **Fort Garland**. Military fort built in San Luis Valley (town of Fort Garland). Reconstructed by the Colorado Historical Society on its original foundation.

1859 **Fort Meribeh**. Log fort built by miners in Summit County for protection against possible Indian attack.

1859–1862 **Fort Namaqua**. Stone trading post and home of frontiersman Mariano Medina, just west of Loveland. A historical marker is located in Namaqua Park.

1860–1867 **Fort Wise/Fort Lyon 1**. Military fort built on Arkansas River (below Bent's New Fort) to protect the Santa Fe Trail. Renamed Fort Lyon during the Civil War. Indians burned the buildings after the army relocated the fort upstream.

1861 **Camp(s) Gilpin.** Temporary militia camps, located in Central City and Golden.

1861–1865 **Camp Weld**. Military post in Denver, built to garrison soldiers in preparation for the Civil War. A fire destroyed most of the buildings in 1864. A historical marker is located on the corner of Eighth Avenue and Vallejo Street in Denver.

1862–1867 **Camp Collins/Fort Collins**. Military camp at Laporte on the Poudre River to protect the Overland Trail. A flood destroyed the camp in 1864. A permanent fort was relocated four miles downstream (old town Fort Collins, between Jefferson Avenue and the Poudre River). No physical remains.

1862–1902 **Fort Francisco**. Trading post and village plaza at the base of Spanish Peaks, built by John Francisco, a former sutler at Fort Massachusetts and Fort Garland. The buildings were refurbished and opened as a museum in La Veta.

1863–1865 **Camp Fillmore**. Camp occupied by Colorado militia near Boone (east of Pueblo) during the Indian wars. No physical remains.

1864–1865 **Civilian stockades**. Defensive structures built against possible Indian attacks: Fort Junction (Longmont), Fort Chambers (Boulder), Parker stockade, Franktown stockade (Castle Rock), Fort Lincoln (Larkspur), Colorado City fort (Colorado Springs), Gray's Ranch station (Trinidad). Historical markers are located on the sites for many of them.

1864–1868 **Fort Wicked**. Home and business of Holon Godfrey family, who held off a three-day Indian attack near Merino. A historical marker is located on US-6 and CR-25.

1864–1868 **Camp Tyler/Camp Wardwell/Fort Morgan**. Military post to protect the Overland Trail (in Fort Morgan). A historical marker is located in a city park on Grant Street.

1864–1871 **Camp Rankin/Fort Sedgwick**. Military post near Julesburg to protect the Overland Trail and railroad construction. A historical marker is located on CR-28.

1866 **Fort Stevens**. Military post on Huerfano River, never completed. No physical remains.

1867 **Post at Pueblo**. Temporary military camp used while Fort Reynolds was under construction.

1867–1872 **Fort Reynolds**. Military post on the Arkansas River to protect settlers against Indian attacks. A historical marker is located one mile east of Avondale on US-50.

1867–1897 **Fort Lyon 2**. Original post was relocated to the west, on the Arkansas River (near Las Animas). Later used as a sanatorium, a hospital and most recently a prison.

1868 **Post at Trinidad**. Temporary military camp, formed in response to an ethnic war between Anglos and Hispanics.

1868 **Fort Washington, Quick Ranch Fort, David McShane Fort**. Settlers' forts around Palmer Lake for protection against possible Indian attack.

1869 **Camp Monument**. Temporary military camp occupied during Indian wars. Originally called Henry Station.

1870 **Fort Cedar Point, Post at Reed's Springs**. Temporary camps for protection of the Kansas-Pacific Railroad construction. Fort Cedar Point sat along I-70 and Post at Reed's Springs on US-24.

1878–1880 **Cantonment at Pagosa Springs, Fort Lewis 1**. Military post built to discourage fights between miners and Ute Indians. The site is now a city park in Pagosa Springs on Hot Springs Boulevard.

1879 **Cantonment on the Rio Mancos**. Temporary military camp occupied after Meeker Massacre to protect miners (present site of Mancos).

1879 **Fort Flagler/Camp at Animas City**. Temporary log stockades built by citizens along the Animas River (Durango) to protect miners. Troops from Pagosa Springs moved in later and camped along the river.

1879 **Fort Defiance**. Log fort built by prospectors (near Carbondale) to guard against possible Indian attack .

1879 **Fort DeRemer**. Stone structures built near Texas Creek (Cañon City) by Denver & Rio Grande Railroad employees during the "Royal Gorge War," a dispute between the two competing railroad companies.

1879–1883 **Cantonment on the White River**. Military camp occupied after Meeker Massacre (in Meeker). Officers' quarters were refurbished and are now used for the White River Museum.

1880–1890 **Cantonment on the Rio Plata, Fort Lewis 2**. Military post on La Plata River near Hesperus. Later used as an Indian school and then a campus of higher learning. The old fort site is now part of the San Juan Basin Research Center.

1880–1891 **Cantonment on the Uncompahgre, Fort Crawford**. Military post built on the Uncompahgre River. A historical marker is located on the west side of US-550, seven miles south of Montrose.

1885 **Fort Narraguinnep**. Log fort built by ranchers for protection against Indians in the San Juan mountains. A U.S. Forest Service sign marks its location, about twenty-five miles northwest of Dolores.

1887–1946 **Fort Logan**. Military post on 640 acres south of downtown Denver. The field officers' quarters are now a museum.

CONTESTED BORDERS
(1806–1822)

At the turn of the nineteenth century, the fledgling United States hungered for new territory. To the west of the Mississippi lay uncharted and unpopulated terrain of striking contrasts: towering mountain ranges, expansive plains and verdant valleys. Yet that wide swath of land was alternately claimed by the British, Spanish and French. In a political topography defined by competing interests and contested borders, European nations stood in the way of America's desire to extend its influence across the continent.

Americans eyed the Louisiana Territory, 828,000 square miles stretching from the port of New Orleans up through the Mississippi basin, to the eastern edge of the Rocky Mountains. Spain had claimed that land in 1800 but had agreed to transfer portions to France in a treaty. Their negotiations dragged on for years, and before the two nations could settle the details, an impatient Napoleon Bonaparte slapped a For Sale sign on the territory. Desperate for cash, Napoleon offered it to the United States for a bargain: a mere $15 million (three cents an acre). President Thomas Jefferson readily accepted Napoleon's offer, effectively doubling the size of the country. In the process, he made an enemy of Spain.

During the confusion of land transfers between Spain, France and the United States, the borders of the Louisiana Territory were not clearly drawn. Spain argued that the land included no more than the western bank of the Mississippi, while the United States claimed it comprised the entire Mississippi watershed, extending as far west as the Continental Divide. In an effort to secure U.S. sovereignty, Jefferson commissioned several expeditions

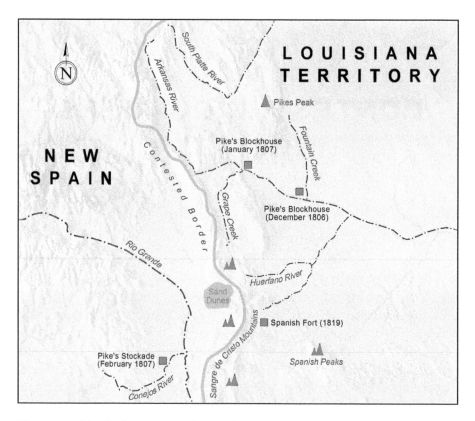

The contested border between America and Spain in 1806–7, showing the first American-built forts on Colorado land. *Map by Sean Gallagher.*

to explore Louisiana. Lewis and Clark first traveled up the Missouri River and over the Rockies, ultimately reaching the Pacific Ocean. The Freeman-Custis team then explored the Red River Basin, seeking a trade route to Santa Fe. Later, the commanding general of the United States Army and new governor of Louisiana James Wilkinson, ordered an expedition into the southern Rockies.

Leading this third expedition was a young lieutenant named Zebulon Pike. Within six months, a vicious winter would force Pike's team to construct a shelter in the San Luis Valley. His stockade was the first of many forts where Americans would lay claim to the Rocky Mountains and the grassy plains—land that would become the future state of Colorado.

What, Is This Not the Red River?

At age twenty-seven, Pike already proved he could lead successful expeditions up the Mississippi. He was confident that he could chart the Arkansas River into the Rocky Mountains as well and then locate the headwaters of the Red River. The Freeman-Custis expedition had failed to reach the Red's headwaters when confronted by Spanish troops, forcing the group of scientists to turn around. It then fell on Pike's shoulders to succeed where Freeman-Custis had failed, and as Pike would soon learn, General Wilkinson had assigned him a near impossible task. The Red River did not flow from the Rocky Mountains as some early maps suggested. Instead, its headwaters rose from the Texas Panhandle. Nor did Pike understand how far his journey would take him. Assuming his expedition would return by early autumn, he and his men dressed only in thin summer uniforms. They neglected to pack coats, woolen socks or extra food.

Joining Pike was a team of nineteen enlisted men, a volunteer doctor named John Robinson and his interpreter Baronet Vasquez—all young men whom Pike affectionately called his "damned rascals." They began their journey from Fort Bellefontaine, Missouri, in the summer of 1806. First, they escorted a delegation of Osage Indians up the Missouri River and then turned south to the Arkansas River. There his team splintered into two groups. He ordered six soldiers to explore downriver to the east while Pike and the remaining fifteen men traveled west. Along the route, he stumbled upon a trail of beaten-down grass and trash-littered campsites. Pike immediately suspected that Spanish troops planned to intercept them as they had with the Freeman-Custis group. Careful not to overtake the Spaniards, Pike slowly followed their trail into the mountains.

Farther upriver, Pike spotted a large blue cloud to the northwest. Examining it closer with a spy glass, he realized that it wasn't a cloud at all, but a grand peak looming ominously over the plains. Day by day they marched toward the mountains, never seeming any closer. With their supplies running low and their eastern-bred animals dropping dead from lack of grass, the team finally reached a major tributary flowing into the Arkansas in November (at present-day Pueblo). Needing shelter and food, they made camp along the river and constructed a log blockhouse—possibly the first structure built by white Americans in the region. They cut fourteen logs, stacking them five feet high on three sides, with one side open to the river.

All the while, Pike couldn't take his eyes off the grand peak. He thought surely they could make a side trip to climb it, a day's trip at most. With

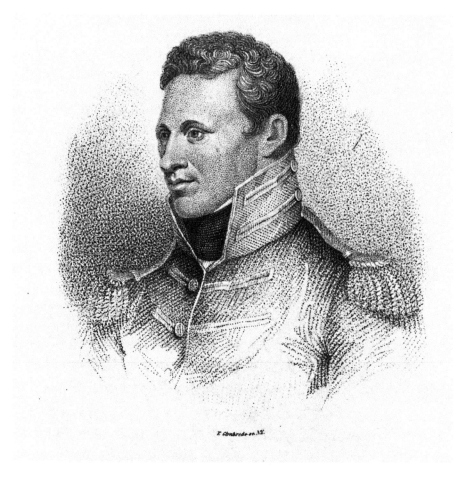

Portrait of General Zebulon Pike as he appeared during the War of 1812. *Courtesy Library of Congress, Prints & Photographs Division.*

three others, Pike struck out for the blue mountain. The men slogged through deep drifts of snow, only to reach the base two days later. After another hard day of hiking, they ascended a peak to discover a depressing sight. To their dismay, the blue mountain rose above them to the north, at least fifteen miles away. After realizing they had climbed the wrong peak, Pike turned around and grumbled that the blue mountain was impossible to scale. He wrote in his journal: "I believe no human being could have ascended to its pinical [*sic*]."[1]

Continuing their mission, the men abandoned their log shelter and rode west through icy creeks and snowdrifts. Once they successfully charted the Arkansas River deep into the Rockies, Pike set his sights on the Red River.

But to his dismay, creeks and canyons led to dead-ends. Snowstorms blinded him. High canyon walls blocked his view. Completely disoriented, Pike looped back until they reached a former campsite at the base of the Royal Gorge. Only then did Pike realize they had wandered in a wide circle. Defeated, Pike wrote in his journal, "I now felt at considerable loss how to proceed."[2]

In the crushing grip of winter, the stubborn lieutenant refused to abandon the mission. Until he found the Red River, he could not report back to his commanding officer and mentor, General Wilkinson. No matter what the cost, no matter what pains his men suffered, Pike would keep pushing. Pike ordered the men to build another blockhouse near present-day Cañon City. This time, he told his interpreter Baronet Vasquez and a private to stay behind with the emaciated horses, their dress uniforms and heavier supplies. Turning south, the remaining thirteen men marched on foot through waist-deep snow while carrying seventy-pound packs on their backs. Although they wrapped their feet in shredded bits of blankets inside their boots, the added protection wasn't enough. Several men had stepped in creek water and walked on ice-encrusted feet, eventually causing them to collapse in agony. Sympathizing but not stopping, Pike left the men where they fell. He provided them with the remainder of their food and then promised to return. The group continued over the Sangre de Cristo Mountains, finding abundant deer to hunt but leaving yet another man behind who could no longer walk.

Over a mountain pass, Pike stumbled into a startling landscape of snow-covered sand dunes and a major river cutting through a broad valley beyond. Encouraged, Pike assumed he had discovered the Red River and marched his men south until they reached it. Up a tributary, he located a grove of cottonwoods they could use for building a stockade, with a steep hill nearby where he could post a sentry. They would need shelter not just for warmth but also for defense. If the Spaniards discovered them, his men might be forced to fight behind its walls.

As the icy winds blasted through the valley, the men piled logs thirty-six feet square and twelve feet high. Inside they dug a shallow ditch along the walls and then planted sharpened stakes to project menacingly over the top. When it was finished, Pike raised the American flag. It's possible he didn't realize that they had crossed over the fuzzy boundary of Louisiana Territory. His stockade sat squarely in New Spain.

In any case, Pike had prepared for Spanish visitors. In his journal, he wrote about the fort's unique method of entry and its defensive attributes:

Our mode of getting in was to crawl over the ditch on a plank, and into a small hole sunk below the level of the work near the river for that purpose. Our port-holes were pierced about eight feet from the ground, and a platform was prepared to shoot from. Thus fortified, I should not have had the least hesitation of putting the 100 Spanish horse[men] at defiance until the first or second night, and then to have made our escape under cover of the darkness; or made a sally and dispersed them, when resting under a full confidence of our being panic-struck by their numbers and force.[3]

When the stockade was complete, Pike ordered a five-man detail to fetch the injured men left in the mountains. At the same time, Pike's doctor asked for permission to leave the group. Dr. Robinson was anxious to complete some business dealings in Santa Fe to the south. Although some of his men needed medical attention, Pike allowed it. The doctor was a volunteer, not officially under his command. As the doctor walked south, the Pike team continued to fortify the stockade by digging a ditch, four feet wide and two feet deep, around the outer walls. Then they drained river water into the moat. If they were forced to make a stand against the Spaniards, they would need access to water.

The crisp winter days passed peacefully, and the rescue party returned with just one of the injured men. Pike's corporal reported that the other two could not walk on their frostbitten feet. The corporal then handed Pike a gruesome gift. In a desperate plea not to be forgotten, the crippled men had sliced off their frostbitten toes for Pike to keep as a reminder. Pike was horrified, insisting that of course he would never leave them to die. He wrote, "little did they know my heart, if they could suspect me of conduct so ungenerous."[4] Immediately, Pike ordered another detail to retrieve the men and horses at the Arkansas shelter and then swing back to rescue the disabled boys.

Pike saw no signs of Spaniards until mid-February 1807. While he was out hunting, the sound of his gunshots echoed through the valley and revealed his location to two riders nearby. Pike remained calm as a Spaniard and his Indian scout approached. He greeted them and played innocent, claiming that he was on a hunting excursion. But the Spaniard wasn't fooled. He said they had met Dr. Robinson in Santa Fe, an encounter that aroused their suspicions that more Americans had entered their territory. The Spaniard tried to wrangle as much information from Pike as possible. How many men did he have? Where were his horses? Why was he here? Pike knew he couldn't shake him. He invited the Spaniard and Indian scout back to

Reconstruction of Pike's stockade, with the sentry hill shown in the background. The stockade is a National Historic Site, open in summer. *Photo by Sean Gallagher.*

the stockade, offered them food and tried to answer their questions politely without revealing details of their expedition. When finally they left, Pike knew more Spaniards would come calling.

A week later, Pike's hilltop sentry alerted them to riders approaching the stockade. Two Spanish lieutenants from an advance guard cordially greeted Pike. They wanted to question him. Pike complied, inviting the officers inside the stockade for breakfast. As he motioned toward a small hole dug under the logs, the Spaniards looked at him strangely—was that the only entrance? Grudgingly, they followed Pike by crawling on all fours over the plank, then scooting on their bellies through the opening. Once inside, the officers dusted off their fine uniforms and asked Pike why he had entered Spanish territory. Pike insisted he only sought the Red River, part of the United States. The Spaniards shook their heads, informing Pike that he was mistaken in his geography. Pike interrupted them. "What…is not this the Red River?" he asked.[5] The officers told him that no, he was on the Conejos River, a tributary of the Rio Grande. He had missed the Red River by five hundred miles.

Outside, Spanish soldiers surrounded the stockade. Pike crawled out and ordered his men to lower the American flag. The Spanish officers insisted on escorting them to Santa Fe, mildly promising not to take them prisoner because their countries were not officially at war. Pike said he would go nowhere until his entire team regrouped. He explained that two

of his men lay injured in the mountains, two remained on the Arkansas with their horses and another two had marched out to retrieve the others. After a heated exchange, the Spanish officers finally agreed to round up all six men. Pike wrote:

> *My compliance seemed to spread general joy through their party, as soon as it was communicated; but it appeared to be different with my men, who wished to have "a little dust," as they expressed themselves, and were likewise fearful of treachery.*[6]

Pike told his men to pack their belongings and go quietly. After the journey south with the Spanish cavalry, Pike's team presented a sorry sight in the bustling village of Santa Fe. Wearing only tattered clothes, their coarse appearance mortified Pike, particularly when the villagers asked if all Americans lived in camps like Indians. Despite their ragged attire, the Spanish governor of New Mexico, Joaquin Alencaster, treated them to elegant dinners, fine wines and fandangos with ladies of the night. Meanwhile, the two Spanish lieutenants kept their promise and sent patrols to retrieve all his men left behind. The crippled soldiers received medical attention in Santa Fe, although they would never walk again.

As the Americans recuperated, the governor told Pike that the commandant general of the Internal Provinces Nemesio Salcedo wanted to question him further in Chihuahua. His escort would be Lieutenant Facundo Melgares, the commander who had led his forces the previous autumn in a failed attempt to intercept Pike. Possibly annoyed that Pike had eluded him, Melgares was at first aloof with Pike and told him he could not take notes while in Spanish territory. The request didn't faze Pike. On the long trek to Chihuahua, Pike pretended to have stomach troubles. He made frequent visits to the bushes and frantically wrote in notebooks, reporting on Spanish forces and the terrain, information that could prove valuable to his commander. At night, he rolled up his journals and stuffed them down the barrels of their empty firearms. If Melgares noticed, he looked the other way. Over the weeks, Melgares had slowly warmed to the American officer, a man much like himself. When Melgares and Pike finally parted ways, they pledged their friendship and hoped to meet again under better circumstances.

In Chihuahua, Pike submitted to more questioning at military headquarters. After the meeting, the Spaniards had no reason to detain him further. They eventually escorted him back to the American border in July 1807, one year

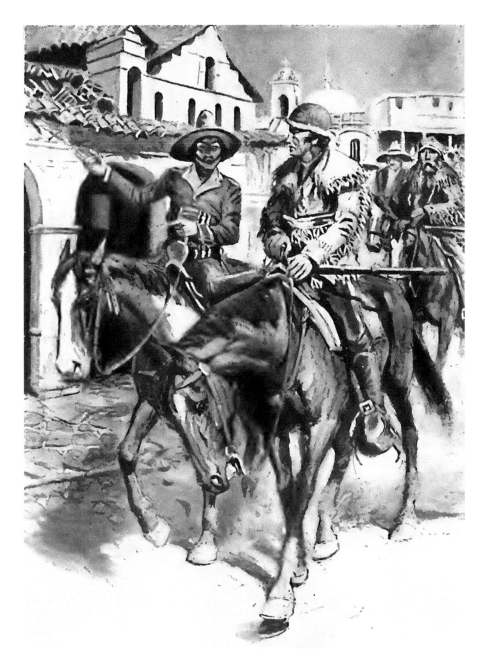

The Spaniards escort Pike and his team into Santa Fe for questioning. *Illustration from* The Boy's Story of Zebulon Pike.

after his team departed. After such an important expedition, he assumed he would receive a hero's welcome like Lewis and Clark before him. Instead, he received the cold shoulder from St. Louis citizens. While Pike was gone, American gazettes had buzzed with news of a growing scandal that involved Pike's commander. General Wilkinson was suspected of plotting to create a new empire southwest of the Mississippi, an isolated territory that he planned to govern with the former vice president, Aaron Burr. Although Burr was arrested and put on trail, there was no direct evidence to convict him, nor could anyone establish Wilkinson's involvement. Not until a full century after his death did Spanish documents surface that proved he was a double agent. Wilkinson had tipped off Spain about the Freeman-Custis expedition and the Pike expedition as well.

To this day, historians still argue over the role Pike may have played in the Burr-Wilkinson scandal. Was he a spy for Wilkinson? Or was he an innocent explorer? There is no doubt that his detailed journals enlightened eastern Americans about the Southwest and helped pave the way for ongoing exploration and development of trade routes into Santa Fe, but in his lifetime, Pike never received the credit he was due. Ironically, Pike's name would become synonymous with the grand peak he never scaled. Almost fifteen years after he tried to climb it, members of the Stephen Long expedition reached the pinnacle. They named it James Peak for Dr. Edwin James, the first white American to set foot on its summit. Stubbornly, mountain trappers called the blue mountain "Pikes Peak," refusing to acknowledge Dr. James.

As for Pike's stockade, the logs decayed and washed away in the Conejos River. Through Pike's detailed notes, pioneers and historians identified its location in 1910. Evidence of a man-made ditch still remained along the river. To preserve the site, the State of Colorado purchased land around the foundation in 1925. Then in 1952, the Colorado Historical Society reconstructed the stockade, which is now a National Historic Landmark and open to visitors in summer.

From the Heads of Spaniards

By 1818, the New Mexico province needed a new governor. Facundo Melgares, the man who escorted Pike to Chihuahua, was Spain's choice for filling the position. As a seasoned military officer, Melgares had defended

Spain against both Americans and Indians and suppressed local uprisings as well. At the time, Spain prohibited New Mexican citizens from doing business with outsiders. As governor, Melgares would guard the passes and trails against American interlopers seeking trade opportunities. However, Melgares had only a handful of experienced regulars at his service, along with a poorly trained local militia. Their reconnaissance missions were ineffective in protecting the main routes into Santa Fe.

In the spring of 1819, Melgares ordered a defensive fort built along the Old Taos Trail, on the eastern edge of the Sangre de Cristo Mountains. The fort was a small, 120-foot-square structure of stone and logs, with a garrison ranging from six to several dozen soldiers. Just six months after the fort's construction, one of its soldiers stumbled into Santa Fe. Weak and wild-eyed, the man reported that the fort had been attacked by Indians, or maybe men dressed as Indians, he couldn't be sure. He described to Melgares how he and fellow soldiers had fought valiantly for hours. After their ammunition was spent, the Indians moved in for the kill. All his comrades lay dead on the mountainside. Only he had escaped.

Furious, Melgares immediately sent three hundred men to chase down the culprits. When the troops arrived at the fort, they found the bodies of their fellow soldiers, scalped and stripped. They buried their dead and then scoured the mountains and plains for hundreds of miles. They found no trace of Indians or Americans.

The fort's attackers remained a mystery for another year until the Stephen Long expedition visited a Pawnee village on the Missouri River in 1820. There, the warriors bragged about a recent raid they made into Spanish territory. They pointed to a pile of booty from the attack, including Spanish clothes and silver coins. The Long team also noticed fine horses grazing around the village, many with Spanish brands. The expedition's doctor, Edwin James, wrote about the scalps the Pawnee showed them:

> *I thought that some of the hair which streamed in the wind from numerous portions of human scalps, suspended on sticks from the roofs of the lodges, was taken from the heads of Spaniards.* [7]

The Spanish fort remained garrisoned until 1821, after the United States and Spain had finally settled their border dispute. In the Adams-Onis Treaty, the two countries agreed on a dividing line that sliced through the future state of Colorado, running east–west along the Arkansas River and then cutting north from its headwaters to the forty-second parallel. Not long after,

the Spanish crown formally recognized Mexico's independence. Melgares, forced to step down from office, was the last Spanish governor to rule over future Colorado land.

With the contested border between America and Mexico finally resolved, the fort lay abandoned. Over the years, travelers camped by its ruins, until its logs and stones scattered into history. Although the exact site is not known, nor Spain's name for the fort, Spanish documents and travelers' journals point to a location five miles down the eastern side of La Veta Pass, on a grassy hill above Oak Creek. In the 1930s, historians located a quadrangle of stones on private property that mark what appear to be the outer walls. Although they found no artifacts, they noticed shallow holes dug all around the site, indicating that treasure seekers may have extracted evidence of what became known in Colorado as "the Spanish fort."

TRADING POST WARS (1822–1842)

After the Pike expedition, Pike's interpreter, Baronet Vasquez, had some wild stories to tell back home. Only a handful of courageous souls had ventured into the Rocky Mountains in 1807, and even fewer dared enter Spanish territory. Vasquez probably enjoyed his celebrity status among friends and neighbors, spinning yarns about a mountain so high its peak clipped the moon or buffalo herds so immense they parted rivers like the biblical Red Sea. His tales fed the imagination of local boys who would soon mature into men, ready for quests of their own. Among them were Baronet's younger brother Louis and the boys of neighboring families, like Charles and William Bent.

In the early 1820s, the profitable fur trade lured these young men into the mountains. Some trappers like Louis Vasquez raked in more money in a month than most eastern shopkeepers could earn in a year, but in less than a decade, the beaver were over-trapped to near extinction. Some decided they could earn a living by selling American-made goods in New Mexico, now open to outsiders. Yet the Santa Fe Trail was slow and dangerous, a painstaking fifteen miles a day for over eight hundred miles from Missouri, with Comanche and Kiowa sporadically attacking the southern stretch. Still, the potential for enormous profits far outweighed the risk. In two trading seasons, Charles and William Bent amassed an astounding $190,000 in silver, gold and goods.

Although hauling wares to New Mexico was lucrative, young William Bent looked for new opportunities. As he made plans for a trading post on the eastern plains, his old friend Louis Vasquez drew plans of

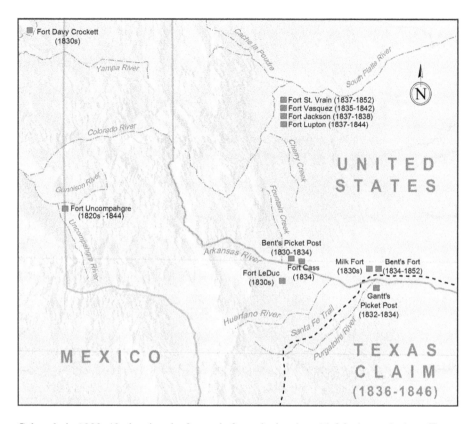

Colorado in 1822–42, showing the fur-trade forts, the border with Mexico and a later Texas claim. *Map by Sean Gallagher.*

his own. Others would soon follow—trappers, soldiers and aristocratic gentlemen—all converging on the future state of Colorado. Before long, trading posts sprouted like weeds. However, this sparsely populated region offered limited financial opportunities, just enough for one trading post to succeed.

LITTLE WHITE MAN

Around 1830, William Bent and several companions descended from the southern Rockies. In his early twenties, Bent had compiled an impressive frontier resume. With his brother Charles, he had worked as a trapper on the upper Missouri and as a trader in Santa Fe. Now Bent and his men were

trapping beaver in the same area where Pike had wandered in circles two decades before. On the north side of the Arkansas River (near present-day Pueblo), the Bent crew built a stockade for their season's furs, dubbing it Fort William. The fort included several stone cabins, built inside the perimeter of picket posts (logs that were sharpened to a point and staked with their spiked ends projecting up). Fort William's exact location is not known. Some historians pinpoint a site between Cañon City and Pueblo while others insist it lay several miles below the mouth of Fountain Creek.

Near the fort, Bent and his employees spent their winter days hunting and trapping under wide-open skies, away from society and city jobs, without clocks, desks or walls to confine them. At night, they huddled by campfires, cooking strips of deer meat and sharing stories of home until sleep overtook them. Although Bent engaged in the rugged vocation of a fur trapper, he could have chosen any profession. His father, Silas Bent, served as a Supreme Court justice in Missouri, his wealth and status opening doors for all eleven of the Bent children. William could have worked in St. Louis, helping to support his mother and younger siblings after their father's death. He could have attended college like his brother Charles, ten years his senior, or continued to sell wares in the cities. Instead, William shunned city life, though he demonstrated a keen acumen for big-city business, particularly for touchy negotiations in tense circumstances.

When Bent built his picket post, he realized his establishment sat in the crossfire between warring tribes. To the west, the Utes roamed the mountains. To the east, the Cheyenne and Arapaho hunted on the plains. To the south, the Comanche and Kiowa controlled the land. Wisely, Bent built his post on a no-man's land, where no tribe claimed the hunting grounds. Of all these bands, the Cheyenne were the first to approach Fort William. One winter day, an amiable chief named Yellow Wolf rode into the post with his hunting party. After the Cheyenne and Americans smoked together and traded small items, the two groups agreed to trade again in the future. As Yellow Wolf moved on, two of his men stayed behind to learn more about the white trappers. They called William "Little White Man," a reference to his short stature.

A few days later, a band of Comanche rode hard and fast toward the post. Bent knew the Comanche could only want trouble, since they were longtime enemies of the Cheyenne. If they discovered the Cheyenne at his fort, they would kill them all. Hastily Bent motioned for his Cheyenne guests to hide under beaver pelts. Then he boldly walked out alone to meet the Comanche, his palms out-turned in a sign of peace. Bent showed

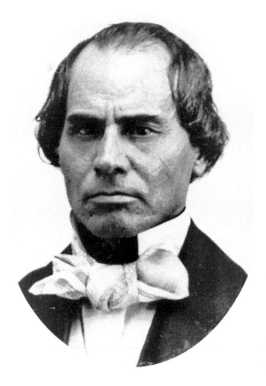

Portrait of William Bent (Little White Man).
Courtesy History Colorado (Scan #10026616).

no fear before the Comanche leader, Bull Hump, a fierce warrior whose name sent shivers through the spines of every Mexican, Indian and white man in the territory.

When Bull Hump angrily motioned at the Cheyenne moccasin tracks leading into the post, Bent had to think fast. Because every tribe wore unique footwear that left distinct tracks, Bent couldn't deny that the Cheyenne had visited. Bent used hand signs to explain that the Cheyenne had already left, gone north with their tribe. Bull Hump didn't believe him. The Comanche men dismounted and poked around the cabins. When they found only the white trappers inside, the Comanche warriors swung up on their ponies and rode away. The relieved Cheyenne men emerged from beneath the pelts, pledging their life-long friendship to Little White Man.

After the ordeal, Bent traveled to Taos with his beaver pelts, a mediocre haul for the season. Continuing on to Santa Fe, he later met Charles, who had brought along their younger brothers: George, age eighteen, and Robert, age sixteen. William told his brothers about his confrontation with Bull Hump and his new bond with the Cheyenne people. Without a doubt, the Cheyenne partnership could provide a new source of income, and brother Charles considered the possibilities. Now that eastern factories demanded leather for boots and belts, Charles saw opportunity in buffalo hides. Buffalo roamed the plains in the thousands, but only the Indians were expert at hunting them and dressing their hides. If they built a bigger trading establishment, something better fortified, they could attract more trade with the Indians.

Such an ambitious enterprise would require a substantial investment. Charles consulted with his business partner, Ceran St. Vrain, then a

merchant in Taos. Like the Bents, St. Vrain also came from a large and prosperous St. Louis family. The Bents and St. Vrains were well-educated society boys who had spent much of their youth running wildly about the river town, befriending old trappers, Indians and Mexicans—rugged men who influenced their decisions to venture west. The Bents convinced St. Vrain that they could recapture that St. Louis community in a large fort, a grand melting pot of eastern gentlemen and frontier roughs.

Until they could design and build the fort, William Bent would continue trade with Indians at his modest post. To restock their supplies, Bent and his three brothers struck out from Taos with wagonloads of American-made goods, probably including knives, cooking utensils, blankets and clothing that they would exchange for animal hides. The Bents slowly made their

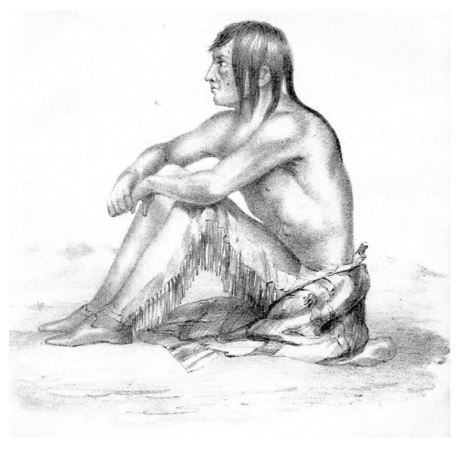

Cheyenne chief Yellow Wolf, who advised the Bents on where to build their fort. *Illustration by James Abert, in* Notes of a Military Reconnaissance.

way over Raton Pass, driving mules and wagons burdened with the weight of heavy goods. The ponderous trip required them to move rocks and chop trees to make room for their wagons, challenging even the most stubborn-minded man. After finally reaching the Arkansas River, William dropped off the supplies with his employees and then left with his brothers downriver to scout for a new fort location.

While camping near the Purgatoire River, William spied his Cheyenne friends riding over the hills. Yellow Wolf greeted him warmly, pleased to reunite with the man who had saved the life of his tribesmen. While the Cheyenne and the Bents relaxed around a campfire sipping coffee, or "black soup," as the Indians called it, William told Yellow Wolf about their plans for an adobe castle on the plains. The brothers couldn't agree on where to build it, though. Yellow Wolf suggested his favorite camping spot downriver at Big Timbers (modern-day Lamar). The spot offered the only trees for hundreds of miles around, with abundant game to hunt. Many different tribes gathered there throughout the year, offering plenty of customers.

The Bents thought it over, but Charles made the final decision. Big Timbers was too far from the mountains, he said. He would select a site closer to his business dealings in Taos. William deferred to Charles but, decades later, wished they had listened to Yellow Wolf.

Damn the Government

In 1832, a disgraced army veteran rode into the Arkansas Valley. Captain John Gantt could never return to the army, not after he was court-martialed for falsifying paychecks. Unemployed and desperate at age forty-two, Gantt decided to seek his fortune in beaver pelts, even though the market had sharply declined. After his trapping expedition failed miserably, Gantt rode for New Mexico to resupply and purchase mules. Along the way, he met with some Arapaho men who convinced him to abandon fur trapping and build a trading post instead. Taking their advice, Gantt built his first stockade at the junction of the Arkansas and Purgatoire Rivers (present-day Las Animas). A sole description of this fort came from the soon-to-be-legendary Kit Carson, an uneducated man of twenty-three who worked for Gantt. In his biography, Carson said the post included a few log buildings where they holed up in winter with no corral for their animals.

For the previous eight years, Carson had worked as a trapper and hunter from the Rocky Mountains to the shores of the Pacific, drifting wherever fate blew him. Although still young, Carson soon proved invaluable to Gantt. In the spring of 1833, Carson accompanied the Gantt crew on a northern trapping expedition. Before they left, they cached (buried) their beaver pelts along the Arkansas River bank. After a few days on the trail, several employees deserted the group. Carson quickly suspected their motives. Volunteering to hunt them down, Carson arrived back at the post, where he found the beaver pelts dug up and a canoe missing. Carson eventually tracked down their mules but not the thieves. In his biography, Carson remarked:

> *I presume they were killed by Indians. Such a fate they should receive for their dishonesty. The animals we recovered and considered ourselves happy; they being of much more service to us than men that we could never more trust.*[8]

Despite the disloyal employees, Gantt's business thrived. The Arapaho, once antagonistic toward whites, openly welcomed Gantt into their lodges. They called him "Tall Crane" and traded their hides for his whiskey. Like many traders, Gantt ignored the ban of alcohol sales to Indians. Some travelers to the region were appalled by his practice. A visiting missionary wrote that the Indians were "wholly averse to drinking whisky but five years ago—now (through the influence of a trader, Captain Gant [sic], who by sweetening the whisky induced them to drink the intoxicating draught) they are a tribe of drunkards."[9] Perhaps unfairly, the missionary blamed Gantt for introducing liquor to the Indians in a time when most traders let whiskey flow freely during their bartering. Some of the more unscrupulous traders would exchange a cup of three-cent whiskey for a three-dollar buffalo hide.

If whiskey was important in maintaining a competitive edge, the location of the trading post was even more critical. In a maneuver to lure business from William Bent, Gantt and his partner, Jefferson Blackwell, relocated their operation upriver in 1834. About six miles below the mouth of Fountain Creek, Gantt began construction for a new post he called Fort Cass (possibly named for the secretary of war, Lewis Cass). He hired Mexicans who were expert at building adobe structures, which offered warmth in winter and cool relief in summer. To make the adobe bricks, the Mexicans combined materials such as clay, mud and straw and then baked them in the sun. When the bricks dried, they would lay the bricks in rows and layer them with adobe mortar for sturdy walls.

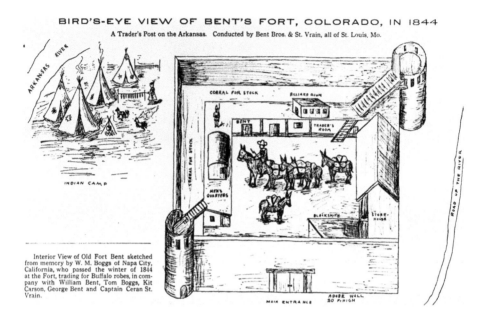

BIRD'S-EYE VIEW OF BENT'S FORT, COLORADO, IN 1844
A Trader's Post on the Arkansas. Conducted by Bent Bros. & St. Vrain, all of St. Louis, Mo.

Interior View of Old Fort Bent sketched from memory by W. M. Boggs of Napa City, California, who passed the winter of 1844 at the Fort, trading for Buffalo robes, in company with William Bent, Tom Boggs, Kit Carson, George Bent and Captain Ceran St. Vrain.

Partial sketch of Bent's Old Fort by William Boggs, an employee of the fort. *Courtesy Denver Public Library Western History Collection, F-11257.*

With the walls of Fort Cass rising near his own post, William Bent continued to meet with Indian tribes and convince them to trade with him instead of Gantt. In the meantime, brother Charles and partner Ceran St. Vrain drew the plans for their adobe castle. They had decided on a location on the Mountain Branch of the Santa Fe Trail, on a big bend in the river (east of present-day La Junta). Their design called for a large quadrangle along the river, the longest side extending 178 feet and the shortest 137 feet (about half the area of a football field). The adobe walls would rise 15 feet high, with two towers at opposite ends, each equipped with muskets and sabers in case of an attack. Outside, they would build a spacious corral of 8-foot walls, with cacti planted on top to discourage horse thieves. Inside, they would construct living quarters on an upper and lower level that faced an inner courtyard. When finished, their fort would be like none other on the plains—immense by the standards of the 1830s.

The Bent–St. Vrain partners hired one hundred laborers in New Mexico and led them over the mountain pass to the empty wilderness. As the Mexicans began laying the adobe bricks, one of them fell sick. His hands and face erupted in pus-filled sores. Before long, the entire camp succumbed to the illness, including William Bent and Ceran St. Vrain. They had contracted smallpox, a

deadly disease. Bent was more worried for the surrounding Indian tribes than he was for himself. He sent uninfected employees around to the villages, warning the Indians to stay away. Back at the fort, some of the Mexican crew died. Bent and St. Vrain eventually recovered, forever bearing the scars on their faces.

The delay cost them months if not an entire year. When construction resumed in 1835, Bent learned that yet another fort had begun operations far to the north. His old acquaintance William Sublette had built Fort Laramie (originally called Fort William in present-day Wyoming), a huge enterprise that would rival Bent's Fort. Despite having just recovered from smallpox, Bent journeyed north to meet all the tribes he could find, persuading them to trade only with him. Then Bent traveled back to his old picket post, its last season before he transferred business to the new fort.

When Bent arrived, he learned that a party of Shoshone was camping near Gantt's Fort Cass. Earlier, some Shoshone had robbed his brother Charles of valuable mules near Taos, an incident that infuriated the Bents. To a white man, horse thieving was as low as murder. But to the Plains Indians, stealing horses proved a young warrior's bravery. Bent probably understood that dichotomy between their cultures, but he couldn't let the thieves go unpunished. At his picket post, Bent barked orders to his ten employees. He told them to grab their weapons and follow him to confront the Shoshone.

When Bent and his men arrived at Fort Cass, they found an Indian agent there. Bent argued with the agent, insisting the Shoshone had stolen Bent-owned animals. If the thieves would not return the animals, he would kill them all. The agent, Richard Cummins, later wrote about their exchange:

> *So soon as I discovered their intentions, I observed to Mr. Bent the step he was about to take was in my opinion an improper one & in all probability would not meet the views of Government…Mr. Bent replied Damn the Government I do it now any how…*[10]

Bent's manager, Lucas Murray, fired the first shot and coldly killed a Shoshone standing near Cummins. All at once, knives were drawn and gunfire exploded. When the smoke cleared, three Shoshone lay dead. Bent's men scalped the fallen Indians, took two Shoshone women prisoner and grabbed thirty-seven animals plus all the guns and goods the Shoshone had in camp. The next day, Bent's men divided up the plunder and gave up the women to Cummins.

The murder of Shoshone Indians was a low point in William Bent's long history of fair dealings with Indian tribes. Perhaps stress played on his state

of mind—the smallpox, the delayed fort construction and the rival forts. Not long after the incident, Bent abandoned his picket post and transferred operations to the new fort downriver. As soon as trade opened there, his adobe castle lured away all Gantt's business, forcing him to shut down Fort Cass. Gantt returned east, broke and unemployed, never imagining the army would want his services again.

In 1835, however, Gantt was recruited as a scout for Colonel Henry Dodge's expedition, an impressive 120-man force charged with a peacekeeping mission to the Plains Indians. Dodge needed a man like Gantt, a former trader who could guide him over unfamiliar terrain. As Gantt led Dodge up the South Platte River and down the Front Range, they found buffalo so thick the prairie turned black. Many of the soldiers had never seen so many buffalo, roaming in the thousands from the mountains to the distant horizon. Gantt passed time with these soldiers, sharing stories about his days trading with Indians and the profits to be made.

When the troops reached the abandoned Fort Cass, Colonel Dodge ordered Gantt to round up Indians from local tribes and meet back at Bent's Fort, the very establishment that forced Gantt out of business. It was surely a bitter pill for Gantt to swallow. As he rode off, he took one last glance at Fort Cass. The walls would soon sink into the mud, lost to history. Similarly, William's picket post would disappear, its old logs chopped up and used for firewood by numerous travelers.

Air-Built Castle

In the summer of 1835, Dodge's troops followed the Arkansas River until they saw the towering adobe walls of Bent's Fort rising from the empty prairie. Here the officers found comfortable quarters inside, a sheltered haven after months of marching through violent thunderstorms, vicious winds and punishing heat in a treeless terrain.

A later visitor described the experience of viewing Bent's Fort for the first time:

> *The dwellings, the kitchens, the arrangements for comfort are all such as to strike the wanderer with the liveliest surprise, as though an "air built castle" had dropped to earth before him in the midst of the vast desert…we were indebted for several days of courteous and really delightful entertainment.*[11]

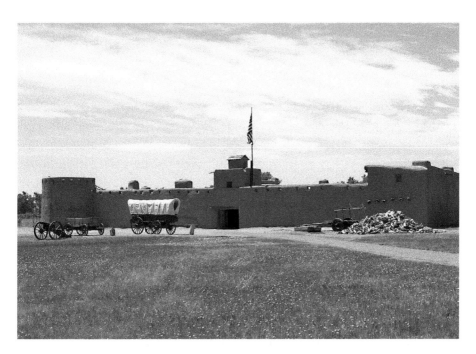

East entrance to Bent's Old Fort, reconstructed using the original designs. The fort is a National Historic Site, open year-round. *Photo by Sean Gallagher.*

One junior officer with Dodge, Lieutenant Lancaster Lupton, experienced the same sentiments of surprise. In this prairie citadel, Lupton and the other officers could relax, chat with the local trappers, listen to music and even play with a pet grizzly bear kept on a leash. Around the courtyard were comfortable rooms on both levels, the adobe bricks providing cool relief from the summer sun. Charles Bent and Ceran St. Vrain offered them refreshing mint juleps and a sumptuous dinner served by the Bents' black slaves, Dick and Charlotte Green. After listening to Gantt's stories and now seeing Bent's Fort, Lupton was surely impressed by the riches to be gained in the Indian trade.

While the officers abided by rules of strict decorum inside Bent's Fort, there were no restrictions outside the walls. Soldiers camped by the river, mingling with the Indians who arrived for Dodge's planned peace council. A journalist serving with Dodge was shocked by the drunken revelry in the Indian camps. He wrote:

> *A party of Spaniards from Taos had been selling them whiskey upon the opposite or Mexican side, and we found a number of them intoxicated. They are very fond of whiskey, and will sell their horses, blankets, and*

*everything else they possess for a drink of it. In arranging the good things
of this world in the order of rank, they say that whiskey should stand first,
then tobacco, third, guns, fourth, horses, and fifth, women.*[12]

Once Gantt arrived with more Indian delegates, Dodge summoned
their leaders into the courtyard. The Cheyenne, Pawnee, Arapaho and
other tribes were all jammed inside the fort walls. With translators at his
side, Dodge delivered a lengthy oratory, explaining how the Great White
Father (President Andrew Jackson) desired the tribes to make peace with one
another. The chiefs nodded their assent, later giving speeches of their own.
When all was done, Dodge felt satisfied that his peace mission concluded
successfully. As the troops prepared to leave, William Bent led his pack mules
into the corral. He had just returned from the Red River, where he had
held a similar council with the Comanche, a daring venture into dangerous
country. He reported that the Comanche also wanted a treaty, a relief to
Dodge and everyone else at the fort.

After the peace councils, William could take a brief respite from traveling
about the countryside in search of new business. His former competitor
Gantt rode away with Dodge, never posing a threat again. His younger
brothers Robert and George joined him in his enterprise, and brother
Charles managed business affairs in Taos, freeing William to serve as chief
trader and negotiator for the local Indians. Around this time, William Bent
also made an important alliance with a highly respected medicine man of
the Cheyenne tribe, Gray Thunder. Bent grew fond of Gray Thunder's
eldest daughter, Owl Woman.

Sometime in 1835, Bent and Owl Woman were married in a Cheyenne
ceremony. Owl Woman never experienced the hard life of most Indian
women, responsible not just for domestic chores around camp but also
for dressing buffalo hides. One visitor at the fort, Lieutenant James Abert,
described Owl Woman as a remarkably handsome woman. Because she was
not obliged to work, Abert said her hands remained soft and delicate, and
her hair was wavy and silken.

Owl Woman occasionally helped guide wagons into the fort gates, but
she did not like William's quarters inside. The fort was noisy with shouting
teamsters, clanking anvils and braying mules—about as peaceful as living
inside a modern-day bus terminal. Instead, Owl Woman maintained a lodge
by the river where the only sounds came from the trickling water and rustling
leaves. Sometimes Bent stayed in the lodge with her; other times, he lived in his
own quarters in the fort. Over the next few years, Owl Woman bore William

three children, each named for one of William's siblings: Mary, Robert and George.

As was the Cheyenne custom, a man of status didn't just marry one daughter; he generally took in the sisters as well. Eventually, Owl Woman's younger sisters, Yellow Woman and Island, also moved into their lodge at the river. Owl Woman would have appreciated the extra help. With her sisters at her side, the days of caring for children were less strenuous. Later, Yellow Woman also bore a child, William's third son, Charley. As the family grew, Bent's sons—Robert, George and Charley—learned to ride bareback and hunt buffalo

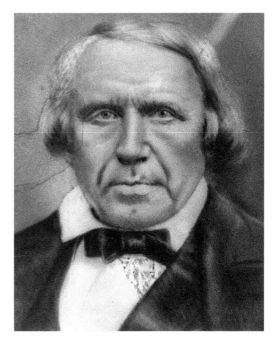

Portrait of Louis Vasquez, owner of Fort Vasquez on the South Platte River. *Courtesy History Colorado (Scan #10030395).*

in the Cheyenne tradition. Daughter Mary learned to sew hide dresses and moccasins with intricate beadwork. With all the different languages spoken around them, they quickly became fluent in English, Spanish and Cheyenne.

In later years, George Bent described his childhood:

> *When I was a boy there were a hundred men employed at the fort, and many of the men had families. There were Indian women of a dozen different tribes living at the fort, and a large number of children. Something was always going on, and we children had no lack of amusements...We could go out and play with the Indian children, or go to the corral back of the fort and watch One-eyed Juan and his men riding and breaking the wild horses.*[13]

With a successful business, William Bent should have relaxed, but he knew that soon, other men would want a piece of his Indian trade. Bent's old friend from St. Louis, Louis Vasquez, scouted for a post location on the South Platte River. Others would come as well, and soon forts would mushroom all along the Front Range.

I Hope to Make a Fortune

Louis Vasquez trapped in the mountains for fifteen years, a lengthy trade that earned him the nickname "Old Vaskiss" at the ripe age of thirty-six. Times were hard in 1834, and Vasquez found himself unemployed that year. He had recently worked for the fur-trading firm of Sublette & Campbell in the Black Hills, but the partnership collapsed. Gone were the days when men could freely trap beaver in the mountain streams and then sell the pelts at the annual rendezvous camps. By then, trading posts had replaced the rendezvous as the preferred method of business. Traders could simply draw the Indians into their posts or meet them at their lodges, where they bartered for hides in exchange for American goods. The Bents had already shown what great profits could be made in the trading post system. Vasquez would do the same.

Along Clear Creek and the South Platte River, Vasquez conducted trade from a post he called Fort Convenience. From here he wrote a letter to his extended family, assuring everyone back in St. Louis that he was in good health. As of late, hard times had fallen on the entire Vasquez clan. In his letter, Vasquez assured the family that he would support them with his new enterprise. He told them to take heart and said, "I hope to make a fortune."[14]

By summer, Vasquez abandoned Fort Convenience and searched downriver for a permanent location near present-day Platteville. With Long's Peak looming over the grassy valley, Vasquez planned a durable adobe structure with rooms surrounding a courtyard. The perimeter would extend one hundred feet square (about the length of a basketball court) with ten-foot-high walls—a much smaller scale than Bent's Fort but much less expensive to maintain.

With Vasquez was Andrew Sublette, the youngest of five Sublette brothers who were all friends of the Vasquez family. Andrew had convinced his older brother William to finance their post, which would be strategically placed halfway between Fort Laramie to the north and Bent's Fort to the south. William Sublette felt confident that Vasquez would make a competent "booshway," a frontier term for the post manager (derived from the French, "bourgeois"). Everyone liked and respected Vasquez, known not just for his work ethic but also for his infectious laughter.

When Fort Vasquez was complete, it included a small gate that led to the river and another main entrance for wagons. Outside were a vegetable garden and a fur press used to compress hides into stackable bales. Vasquez employed twenty-two men, many of French-Canadian, Mexican or mixed

descent. He also hired his twenty-two-year-old nephew "Pike," a nickname his father Baronet gave him after Zebulon Pike died in the War of 1812.

In those initial months, Vasquez operated the only fort on the South Platte. Yet his monopoly would be short-lived once Lancaster Lupton rode in.

I Have No Profession

Only weeks after his triumphant return from the Dodge expedition, Lieutenant Lupton found himself under arrest. Although Lupton was a man who enjoyed lively and convivial conversation, his disposition turned ugly when he drank. At Fort Leavenworth, he and fellow officers imbibed too freely one night, and during the course of the evening, the officers baited Lupton into an argument. Possibly they were jealous that Colonel Dodge had presented Lupton with a brace of pistols for his service. Perhaps they just didn't like the small and scrappy lieutenant. Their fight escalated until Lupton was singled out as the

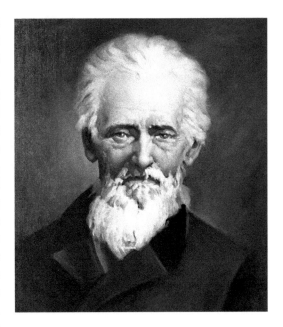

Portrait of Lancaster Lupton in his later years. From an oil painting by Waldo Love. *Courtesy History Colorado (Scan #10041589).*

instigator. The military charged him with conduct unbecoming an officer, public drunkenness and speaking disrespectfully against the president of the United States.

Hoping to clear his name, Lupton fought the charges. As a West Point graduate, he knew no other life but the military and had no plans of leaving. But during the proceedings, Lupton grew tired of defending himself. He later wrote:

> *Educated as I was for the Army and having served many years on the extreme Western frontier, I of course have no profession—The energies of*

my youth and early manhood, the time usually spent by others in learning how to live—have been devoted to the service of my country.[15]

Before his trial began, Lupton resigned his commission in disgust. Deciding on a new career, he signed with a fur trading expedition and worked around the Fort Laramie area. While there, he learned that Vasquez and Sublette were luring away business to the South Platte River. Lupton remembered the area well. During his time with Dodge, he had seen the vast herds of buffalo. Their numbers would provide enough hides for more than just a few traders. Lupton returned to St. Louis to secure financing for a trading post and then set off again in the spring of 1837. With several employees, Lupton traveled up the South Platte to scout for locations.

When the Bent–St. Vrain partners heard about the new competition on the South Platte, they schemed to put them out of business. They sent George Bent to build a rival fort nearby and expand their interests up north. With the Bent's Fort blueprints in hand, George selected a spot on the South Platte about twelve miles east of the Poudre River. He then hired Mexican laborers to begin construction of an adobe fort. When finished, the fort extended 127 by 106 feet (about two-thirds the size of Bent's Fort) with two watchtowers at opposite ends. Inside, the fort included rooms along two walls for storage and living quarters, all facing inward to the courtyard. The Bent–St. Vrain partners initially called it Fort Lookout, apparently so named because it would serve as a lookout for their business interests on the South Platte. Later, they would refer to the fort in business transactions as Fort George, but that name would fade once Ceran St. Vrain put his younger brother Marcellin in charge.

Fort St. Vrain, as it was later known, did not discourage Lupton. He already had the financing, the license and the designs for his own post. Seven miles upstream from Vasquez, Lupton paced out the grounds for Fort Lancaster (although Fort Lupton was the name that stuck). It would be nearly the size and shape of Bent's Fort, with a round watchtower at one end and a spacious storeroom at another. The courtyard was surrounded by living quarters, a kitchen, a blacksmith shop and a store. Lupton's room was on a second story, the only quarters on the upper level.

While Mexicans began the meticulous work of laying adobe bricks, Lupton rode back to St. Louis to hire clerks, traders and hunters. Like all posts of that era, his fort would employ men to meet with Indians coming inside to trade, as well as men who would carry goods to the villages like

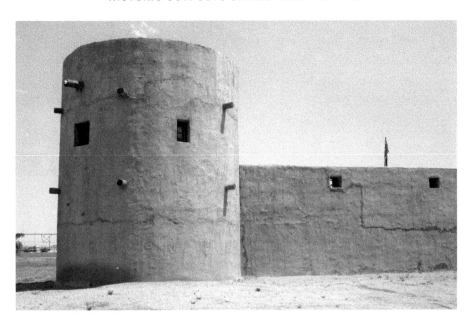

Fort Lupton Historic Park, open year-round. The fort was reconstructed near its original location on the South Platte River. *Photo by Sean Gallagher.*

traveling salesmen. Typically these traders and other fort employees were hired for a year-long contract, earning about $200 per year.

When Lupton returned from St. Louis with employees and trade goods, he discovered a depressing sight. Not only was Fort St. Vrain rising like a castle from the riverbanks, but also yet another trading post had wedged its way in between his own post and Fort Vasquez. Now, four trading establishments all sat within a day's ride of one another—Fort St. Vrain, Fort Vasquez, Fort Lupton and the new Fort Jackson.

Do All the Harm Possible

For nearly thirty years, the American Fur Company monopolized the northwest fur trade. When the trading posts sprang up on the South Platte River, the company owners were none too pleased over the competition. They sent two seasoned mountain men, Peter Sarpy and Henry Fraeb, to build a post right next to the others. Sarpy was raised in St. Louis in a French-Creole family. He was a man of refined tastes yet preferred the freedom of a trapper's life to the confines of the city. Fraeb was a German immigrant who

once helped operate the failed Rocky Mountain Fur Company. Although no records exist that describe the size and shape of their fort, some letters written by employees indicate that it was an adobe construction combined with logs. They named the post Fort Jackson, possibly for President Andrew Jackson, but no documents have surfaced to verify its origin.

In the spring of 1837, Sarpy and Fraeb drew heavy loans for their fort, upward of $11,000. The debt did not worry them. They assured their investors they would soon repay it. Sarpy remained on the South Platte to oversee the construction while Fraeb rode to Fort Laramie on business. From Fort Jackson, Sarpy wrote a letter to Fraeb with plans for how they could first eliminate Fort St Vrain. Sarpy wrote, "My object is to do all the harm possible to the opposition and yet without harming ourselves."[16]

Sarpy learned that George Bent handed over the booshway job to Marcellin St. Vrain, a naïve youth of twenty-two who could easily fall prey to a business scheme. As the spoiled baby of the St. Vrain family,

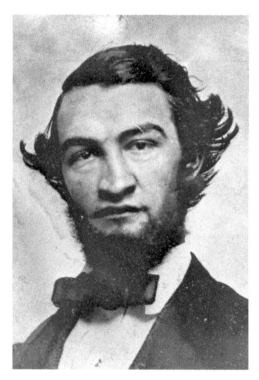

Portrait of Marcellin St. Vrain, the booshway of Fort St. Vrain. *Courtesy History Colorado (Scan #10037980).*

Marcellin had little interest in fort management. The educated dandy shirked his responsibilities, preferring to spend his days drinking, hunting and racing horses. Yet even those diversions wore on his eastern sensibilities. He complained that the sand flies were pesky and decided he would rather be bored to death inside than bitten to death outside.

In the spring of 1838, Sarpy and Fraeb approached Marcellin with a business proposition. They would buy all his buffalo robes for a set price and relieve him of the responsibility of transporting them to St. Louis himself. Marcellin agreed to their deal, glad to be rid of the smelly hides. When all was done, Marcellin tallied the books at Fort St. Vrain. For the entire

season, he profited a measly thirty-two dollars—thousands of dollars short of what he could have earned on his own.

Word of Marcellin's incompetence quickly reached his brother Ceran and the Bents. And just as swiftly, they plotted their revenge on Sarpy and Fraeb. In St. Louis that season, Ceran approached Fort Jackson's investors and offered to purchase all its debt. The investors agreed, making the Bent–St. Vrain partners the new owners. Then William Bent rode up to Fort Jackson with the news. Although Sarpy and Fraeb were not there at the time, Bent informed the employees that the fort was now closed. Bent took stock of their assets and loaded everything he could carry in the wagons.

After the fort was sold, Sarpy landed on his feet. He opened a mercantile in the Nebraska Territory and started a ferry service across the Missouri River. Fraeb wasn't so fortunate. He established a short-lived post with fellow trapper Jim Bridger near present-day Steamboat Springs. One day while Fraeb was out hunting, Indians killed him along the Little Snake River. Fort Jackson was never occupied again and sank into the riverbank.

RIVALED BEDLAM ITSELF

From comfortable homes back east, young men read tales of western adventures. Some risked the journey out west on their own while others hired on with wagon teams. One such man, E. Willard Smith, joined the crew of Vasquez and Sublette in the early autumn of 1839. Smith kept a journal of his travels, writing about the massive herds of buffalo and a band of Pawnee that nearly killed Louis Vasquez. Smith's journals reveal a harsh life on the frontier and the challenging conditions for managing a trading post. By the end of his travels, some of the forts he visited would succumb to those challenges.

Traveling west along the Santa Fe Trail, Smith described his first impression of Bent's Fort as appearing more like a military fortification than a trading post. He also noted a new post just west of Bent's Fort, where mixed-blood families of Mexicans, Indians and Frenchmen grew crops and herded goats. This group sold goat's milk, earning it the nickname of the Milk Fort. Unlike the sophistication of Bent's castle downstream, the Milk Fort was a slapped-together quadrangle of thirty mud huts. Another eastern traveler wrote about the Milk Fort, stating that "there cannot exist in any nook or corner of the wide universe, a wilder, stranger, more formidable

collection of human beings for a civilized eye to look upon."[17] The Mexican women wore nothing but petticoats and shawls, with their faces daubed in vermillion. The men, all armed with knives and pistols, let their beards and hair grow past their shoulders, giving them a wild and ferocious appearance.

Past Milk Fort, Smith's crew plodded up the Front Range for several more weeks, until they finally drove through the gates of Fort Vasquez. Smith said their "arrival caused considerable stir among the inmates."[18] Fort Vasquez teemed with independent trappers, Mexican employees and their wives. Smith wrote:

> *The men at the Fort have been carousing, having got drunk on alcohol. There are about twelve lodges of Shains* [Cheyennes] *encamped at the Fort. They have been trading with the whites. They had a scalp-dance in the Fort to-day, dancing at the music of an instrument resembling the Tambourine.*[19]

Smith enjoyed his time there but was eager to travel into the Rockies. He joined another traders' crew, this time for William Craig and Phillip Thompson, who partnered in a post called Fort Davy Crockett. The post sat along the banks of the Green River at the northwestern tip of Colorado in a verdant valley known as Brown's Hole. Despite the picturesque location, visitors at this fort weren't kind in describing its lodgings. One weary traveler, who was served a watery gruel of boiled dog meat, wrote about the impoverished state of the fort:

> *The fort itself is the worst thing of the kind that we have seen on our journey. It is a low one-story building, constructed of wood and clay, with three connecting wings, and no enclosure. Instead of cows the fort had only some goats. In short, the whole establishment appeared somewhat poverty-stricken, for which reason it is also known to the trappers by the name of Fort Misery.*[20]

When Smith arrived at Fort Crockett, owners Thompson and Craig treated him to a decent meal. There he met the fort's hunter, Kit Carson, who had returned with fresh meat for the twenty men employed there. After leaving Gantt's employ, Carson had wandered to the western slope. For a time, he worked alongside the trappers from Fort Uncompahgre, a trading post at the confluence of the Gunnison and Uncompahgre Rivers (modern Delta). He trapped beaver and sold pelts there, but the season's profits were

Typical quarters of a fort employee during the fur-trade era. The room shown is at the reconstructed Fort Uncompahgre in Delta. *Photo by Sean Gallagher.*

slim, barely enough to support his Indian wife and baby daughter. Instead, Carson decided to seek employment as a hunter at Fort Crockett. Although his job was to procure meat for the employees, Carson found himself tracking thieves yet again.

In winter 1839, nearly 150 horses went missing from the valley around Fort Crockett. The fort owners suspected Indians led them through the narrow canyon and out of the valley. If they attempted to give chase, the Indians would lay a trap on the canyon walls above, prepared to rain arrows down on them. The owners Thompson and Craig argued about what to do. Thompson was hopping mad, impatient to pursue their valuable stock. Craig advised him to wait. Despite his partner's wishes, Thompson rode off with twelve men. They later returned with horses they stole from another trading post up north and a camp of Shoshone nearby. Angry about his partner's rash behavior, Craig advised Thompson to leave quickly before the Shoshone attacked. The argument caused a rift that spelled the end of their partnership and the end of Fort Crockett as well.

As Craig suspected, the Shoshone appeared at their fort and demanded the return of their animals. To calm matters, Kit Carson agreed to help restore the missing ponies and rode off with twenty-five men. Meanwhile, the young

journalist Smith was left behind at the fort with their families. He knew they must leave the valley in case the Shoshone returned to attack them. Smith and the others wrapped themselves in warm clothing, packed three travois of supplies and trekked east through the mountains. The weather was warm and unusually pleasant for mid-January. They sought shelter at trappers' cabins and in the lodges they dragged along. But at each place, they feared for their safety. They kept moving, up over the Continental Divide and toward Fort Vasquez. The fickle weather eventually struck down on them, dumping two feet of snow. Smith and the others huddled in makeshift shelters, near starving, while two men volunteered to go for help. Smith waited out the winter storms for nearly thirty days, and just when they began to lose hope, Smith saw an old friend riding toward him. It was "Old Vaskiss," his first employer. Vasquez had brought supplies and fresh horses, ending their harrowing ordeal.

Smith decided mountain life wasn't for him. Back at Fort Vasquez, he asked for a wagon ride to Missouri. But Vasquez had a different plan for transporting their hides that year. Instead of slow-moving wagons, Vasquez decided to sail back to St. Louis on the South Platte River. He and his crew built a flat-bottomed boat (a Mackinaw-style vessel), thirty-six feet long and eight feet wide, spacious enough to hold the season's seven hundred buffalo robes and four hundred buffalo tongues. Without understanding the shallow course of the South Platte, a seven-man team launched the boat from Fort Vasquez with high hopes of reaching St. Louis before Lupton or Bent. Smith joined them, quickly disappointed by the lack of progress:

> *The water was very shallow and we proceeded with great difficulty, getting on sand bars every few minutes. We were obliged to wade and push the boat along most of the way for about three hundred miles, which took us forty-nine days.*[21]

Once they reached St. Louis, Vasquez couldn't find buyers for his boatload of furs. The Bent–St. Vrain crew had already delivered fifteen thousand robes to the city's merchants, glutting the market. Resigned to their fate, Vasquez and Sublette sold their operation to another pair of businessmen for a mere $800. They never collected the money, for the new owners soon went bankrupt themselves and closed Fort Vasquez.

Meanwhile, Lupton suffered financial difficulties of his own. Instead of selling out, he decided to expand. He opened another post on the North Platte River (in Wyoming) called Fort Platte. The stress of the business must have affected his health. Lupton came down with a severe fever and was nursed back to health by a local Indian woman named Thomass. Their

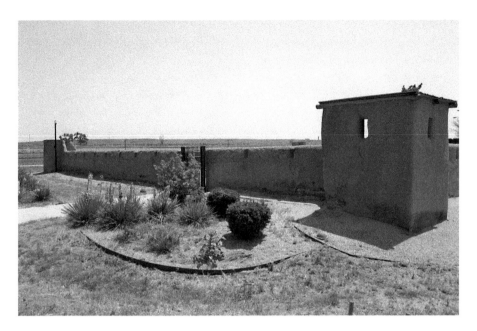

Fort Vasquez reconstruction, near its original location on the South Platte River at Platteville. The museum is open year-round. *Photo by Sean Gallagher.*

relationship blossomed into marriage. Lupton never told his eastern relatives about his wife or the three sons they would soon have. He knew they wouldn't accept his marriage to a "squaw."

For a few years, Lupton's forts were known for their wild celebrations. A victim of intemperance himself, Lupton didn't keep tight controls on the free-flowing liquor. When the writer Rufus Sage journeyed through the region, he observed:

> *The night of our arrival at Fort Platte was the signal for a grand jollification to all hands…who soon got most gloriously drunk, and such an illustration of the beauties of harmony as was then perpetrated, would have rivaled Bedlam itself, or even the famous council chamber beyond the Styx. Yelling, screeching, firing, shouting, fighting, swearing, drinking, and such like interesting performances, were kept up without intermission, and woe to the poor fellow who looked for repose that night, he might as well have thought of sleeping with a thousand cannons bellowing at his ears.* [22]

Sage also recalled an altercation between a man named Beer and another employee named Herring at Fort Lupton. Beer desired Herring's wife and bullied him into a duel. Sage wrote:

> *The weapons selected by Beer were rifles, the distance fifty yards, the manner off-hand, and the time of shooting between the word fire and three. The two met, attended by their friends, at the time and place agreed upon. At the word "fire," the ball of Beer's rifle was buried in a cottonwood a few inches above the head of his antagonist. At the word "three" the contents of Herring's rifle found lodgment in the body of Beer, who fell and expired in a few minutes.*[23]

With these two rowdy forts, Lupton had hoped to increase business. But his gamble didn't pay off. In 1842, he sold Fort Platte and moved his family to a ranch near Fort Lupton. He soon discovered farming was no more lucrative than trading. Winds, grasshoppers and pounding rains ruined his crops. Desperate and broke, he abandoned Fort Lupton and drifted down to the Arkansas River settlements. Lupton tried farming once more, but when the gold rush hit California in 1849, Lupton took his family west. He remained there for the rest of his life, dying at age seventy-eight.

As for Louis Vasquez, he joined Henry Fraeb's former partner Jim Bridger in a new enterprise. Together they established Fort Bridger along the Oregon Trail in 1842, although most of the traffic bypassed their Wyoming fort. Vasquez helped promote a route called the "Hastings Cutoff" to California with Fort Bridger as a launching point. (The trail would go down in history as the ill-fated route of the Donner party.) By then, Vasquez had given up the bachelor's life and married a St. Louis woman. Vasquez lived his final days on a farm in Westport, Missouri, where he died at age seventy.

The South Platte forts stood for many more years, helping to shelter gold seekers and other travelers. Some found new lives as post offices, stage stations, churches and schools, until the expense of maintaining the adobe walls left them empty once again. Between 1935 and 1936, a team of fifty-nine men from the federal Works Progress Administration rebuilt the walls of Fort Vasquez. In 1958, the property was transferred to the Colorado Historical Society, and a small museum later opened at the site.

Fort Lupton was saved from disappearing into history as well. The South Platte Valley Historical Society raised money to reconstruct the adobe post to its former glory. Construction was completed in 2008, and many of the interior rooms are furnished with period pieces and trade goods.

Wretched Species of a Fort

In the autumn of 1842, Charles Bent was fuming mad as he rode into Bent's Fort. He called for his brother William and Ceran St. Vrain. Another post was under construction, he said, with a little community of trappers at the confluence of the Arkansas River and Fountain Creek. They called their post "El Pueblo." Charles said they were selling whiskey to the Indians and threatening the livelihood of Bent's Fort.

Although much smaller than Bent's Fort, El Pueblo was a significant post. The owners hired Mexican laborers to construct the adobe walls, with two bastions on each end, rooms facing a courtyard and gates made of cottonwood logs. Former Bent employees funded the enterprise, including George Simpson, Robert Fisher, Joseph Doyle and Alexander Barclay. Possibly these men never intended to rival Bent's Fort. Because El Pueblo sat along the isolated Mexican-American border, away from authorities, their main business came from a steady stream of illegal liquor sales.

Charles Bent formed a plan to put El Pueblo out of business. The area needed a military fort, a large installation right at the El Pueblo site. That would stop their illegal trade in a hurry. Charles crafted his request to Missouri senators carefully, knowing he couldn't justify the military need with his own business interests. Instead, he described how the Mexicans and the warring Indian tribes created unstable conditions on the frontier. If a military fort wasn't built near El Pueblo soon, the Mexicans may rouse the Indians against them. He wrote:

> *The Mexicans pass over the boundary in large partys* [sic]…*some times as high as three hundred men…and many of them doe* [sic] *not scruple to excite the Indians…*[24]

Charles Bent had good reason to be concerned about the Indian situation. Although the Bents had hosted another peace conference with the tribes in 1840, the prairie was still unsafe for travel. In 1841, while younger brother Robert Bent was escorting their wagons down the Santa Fe Trail, the Comanche ambushed and murdered him. Charles blamed his brother's death on unscrupulous traders for selling liquor to Indians, making them unruly and violent. Despite his appeals to the government, Bent's letters were tossed aside. There would be no military installation along the Arkansas River, at least not yet.

Meanwhile, life at El Pueblo was relatively quiet except for a few domestic dramas. Some employees brought their wives and children to live there, and

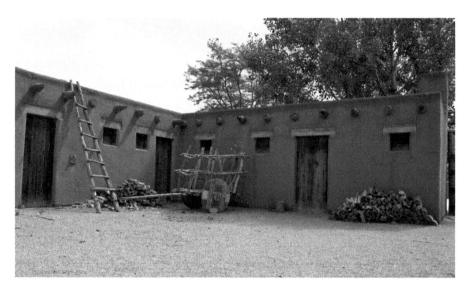

Courtyard of a reconstructed 1840s fur trading post, located at the El Pueblo History Museum. Open year-round. *Photo by Sean Gallagher.*

with few eligible women on the frontier, fort owners George Simpson and Joseph Doyle quickly snatched up the daughters of a Mexican woman named Teresita Sandoval. Although Teresita was married herself, the poised and beautiful woman captured the attention of the former Bent bookkeeper, Alexander Barclay. The Englishman watched Sandoval as she climbed the banks of the river with a pail of water balanced on her head and a blue shawl draped over her bare shoulders. While her husband was traveling, Barclay wooed her away. The pair left the fort together and headed to New Mexico Territory.

Over the years, El Pueblo changed hands numerous times. The original owners moved on, and El Pueblo fell into disrepair. Moving into the rooms was a lowly class of frontiersmen, troublemakers who were banned from respectable establishments. A writer named Francis Parkman described El Pueblo in those declining years:

> *It was a wretched species of fort, of most primitive construction, being nothing more than a large square inclosure* [sic], *surrounded by a wall of mud, miserably cracked and dilapidated. The slender pickets that surmounted it were half-broken down, and the gate dangled on its wooden hinges so loosely that to open or shut it seemed likely to fling it down altogether.* [25]

A rough lot of frontiersmen also gathered at another post in the vicinity, Fort LeDuc, which sat on the eastern edge of the Wet Mountains. In the mid-1830s, French trappers built Fort LeDuc on a path between the mountains and the Santa Fe Trail. It offered a bird's-eye view of the eastern plains, earning its nickname "Buzzard's Roost" (or "El Cuervo," as the Mexicans called it). The rooms were laid out in a square around a courtyard, surrounded by pickets that formed an almost circular shape. In charge were a French trapper, Maurice LeDuc (or LeDoux), and his Ute wife, who encouraged her relatives to trade at the fort. LeDuc spent little time there. Instead, he passed his days hunting on the plains, drinking whiskey and pursuing romantic assignations with the señoritas in Taos. Some stories suggest that LeDuc's jealous wife burned the fort to cinders, while most historians believe it remained in operation until 1854, when Ute Indians attacked and burned it.

Neither Fort LeDuc nor El Pueblo posed a serious threat to the Bents. After the three South Platte forts closed their gates, the Bent–St. Vrain partners won the trading post wars on the eastern plains. However, by the mid-1840s, unstable political conditions had caused a new threat to their business. The upcoming Mexican-American War would prove that Charles Bent had been correct—a military fort was needed in the area.

MANIFEST DESTINY (1842–1849)

As he boarded a Missouri steamship, thirty-three-year-old Kit Carson wondered what to do next. It was 1842, and he could no longer earn a living trapping along the mountain streams. After his Indian wife died, Carson took sole responsibility for his two children. Even if he could support them, he had no clue how to raise two little girls. He left the toddler with Charles Bent's wife and his five-year-old daughter with a niece near St. Louis. With his girls cared for, Carson steamed west again. Perhaps he would return to his job as a hunter for Bent's Fort, where he earned one dollar a day. Perhaps he would seek employment elsewhere, something that paid more.

The answer met him on the ship's deck. A man approached Carson and introduced himself as John C. Frémont, a second lieutenant in the Corps of Topographical Engineers. At age twenty-nine, Frémont was a remarkably handsome and confident man. Although he was raised in poverty, Frémont educated himself and formed important political alliances, even going so far as to elope with a Missouri senator's daughter. But the scandal didn't hurt the ambitious and opportunistic Frémont. Instead, his father-in-law helped him win an appointment for leading the Oregon Trail survey. It would be the first of several expeditions into the West for Frémont, helping America fulfill its desires to expand from the eastern seaboard to the western shores—if only Mexico, Britain and numerous Indian tribes would step out of the way. The obstacles meant nothing to Frémont. He saw himself as the embodiment of Manifest Destiny, the pathfinder who would open the West for American settlers.

Frémont had an immense task ahead—a survey that required him to penetrate dangerous Indian territory and treacherous mountains. Without

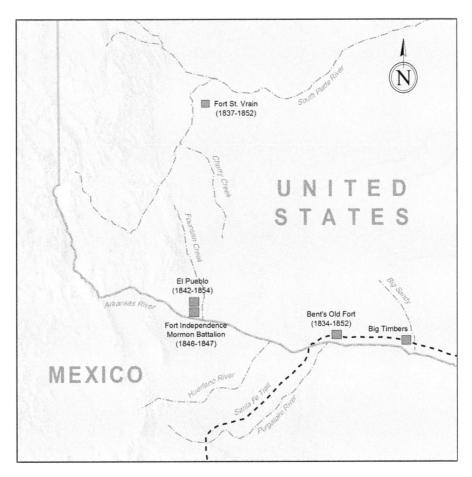

Colorado in 1842–49, showing some of the forts during the Mexican-American War. *Map by Sean Gallagher.*

familiarity of the far west, he needed an experienced frontiersman to guide him. His first choice fell through, and when he could find no one else, someone pointed out Carson on the ship that day. Frémont dubiously eyed the short, soft-spoken Carson. He didn't fit Frémont's image of a larger-than-life mountain man, but Frémont was desperate. He asked Carson if he was up for the job. Carson nodded. "I had been some time in the mountains," Carson later told his biographer. "I could guide him to any point he would wish to go."[26] After several inquiries into Carson's skills, Frémont hired him. The pay would be $100 a month, three times what Carson earned at Bent's Fort.

Thus began Carson's new career. Through tumultuous times, Carson and other frontier scouts would lead men like Frémont on scientific expeditions,

into battlefields of Mexico and against Indian tribes. Along the way, they would stage their campaigns from the old trading posts and newly built forts in future Colorado.

My True and Reliable Friend

In 1842, Carson led Frémont's expedition along the Oregon Trail, where they detoured down the South Platte River to resupply at Fort St. Vrain. Frémont wrote that the fort's booshway, Marcellin St. Vrain, "received us with much kindness and hospitality."[27] After a short stay, Carson helped Frémont chart a safe route over the mountains (South Pass in present-day Wyoming). While Frémont triumphantly reported back to Washington, Carson traveled to Taos.

Carson had another reason for seeking respectable employment that year. Before his trip to St. Louis, he had met Josefa Jaramillo, the fourteen-year-old sister of Charles Bent's wife and the daughter of a respected family. Carson had asked for her hand, but the haughty Jaramillos looked down their noses at the uneducated frontiersman and his "half-breed" daughters. Carson didn't give up easily. With the advice of the Bent brothers, he had converted to Catholicism and put his daughters under the care of friends and relatives. (His youngest daughter would later die, tragically killed when she fell into a vat of boiling tallow.) When Carson finally had money in his pockets, the Jaramillos gave consent for him to marry their daughter.

A year later, Carson learned that Frémont was on the trail again. Frémont had returned in 1843 to Fort St. Vrain, where he wrote in his journal: "About noon, on the 4th of July, we arrived at the fort, where Mr. St. Vrain received us with his customary kindness, and invited us to join him in a feast, which had been prepared in honor of the day."[28] Here, Marcellin treated Frémont's men to an elaborate dinner, serving them delicacies of the day that included macaroni, fruitcake and even ice cream made of goat's milk. To celebrate the nation's independence, they fired off a cannon that Frémont brought with him. The Indians camped nearby also joined the Independence Day celebration, which they referred to as "Big Medicine Day."

Carson rode north just to visit with Frémont but soon found himself under his employ. Frémont asked Carson to purchase mules for him at Bent's Fort and deliver the animals to Fort St. Vrain. When Carson returned with the mules, Frémont asked if he would guide his expedition

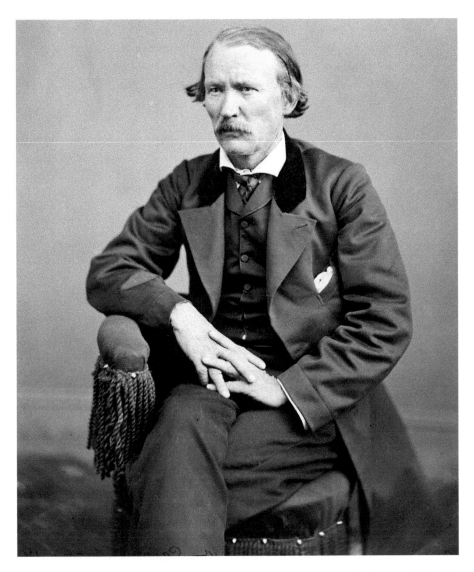

Portrait of Kit Carson, who served as a trapper, hunter and commander for some Colorado forts. *Courtesy Library of Congress, Prints & Photographs Division.*

once again. Carson hesitated, not wanting to leave his new bride, but Frémont was persuasive, offering him a good amount of money.

The second expedition was an exhausting journey, all the way to the Pacific coast and then back in a southerly route the following summer of 1844. When they traveled down the Arkansas River, Frémont wrote about the hearty welcome they received at Bent's Fort:

As we emerged into view from the groves on the river, we were saluted with a display of the national flag and repeated discharges from the guns of the fort, where we were received by Mr. George Bent with a cordial welcome and a friendly hospitality, in the enjoyment of which we spent several very agreeable days.[29]

By the end of their second expedition, Frémont considered Carson "my true and reliable friend."[30] Carson returned to Taos and tried to settle down; he even took up farming for a while. But the frontier, and Frémont, would forever beckon him.

WICKEDNESS AND IDLENESS

During Frémont's first two expeditions, the land south of the Arkansas River and west of the Continental Divide still belonged to Mexico, land that included present-day Utah, New Mexico, Arizona, Nevada, California and the western slope of Colorado. Americans who wanted to establish trading posts on the western slope could only conduct legal business by becoming Mexican citizens themselves. One such trader was Antoine Robidoux, the son of a French-Canadian merchant in St. Louis.

The Robidoux clan had long operated a Missouri fur-trade enterprise that suffered financial difficulties as the northern trade became overrun by large companies in the 1820s. The Robidoux family had to expand their business or soon go bankrupt. They turned their attentions toward Mexico with its flourishing villages of Santa Fe and Taos. Youngest brother Antoine was the best choice to make business connections there. He was fluent in Spanish, as well as French and English. The handsome and charming Antoine would easily ingratiate himself into Santa Fe society.

Antoine Robidoux left for Santa Fe in the mid-1820s. He spent several years traveling on the Mexican side of the mountains, where he successfully opened relations with bands of Ute Indians. With the Ute trade secured, Robidoux returned to Santa Fe in 1826 and applied for Mexican citizenship. But citizenship required a two-year waiting period. During that time, the thirty-two-year-old Robidoux hobnobbed with Mexican officials and socialites. He managed to win an election to the Santa Fe town council and then searched about for a suitable wife. One vivacious and dark-eyed beauty caught his eye: Carmel Benevides, the adopted daughter of

Mexico's governor. Robidoux befriended the governor and received permission to marry the sixteen-year-old girl. Not so coincidentally, the governor also granted Robidoux an exclusive license to trap and trade along the entire western slope before he received official citizenship.

Robidoux didn't waste time after receiving the license. After settling his wife in a Santa Fe home, he led his pack mules and fifteen Mexican employees north through valleys and mountain passes. They traversed three hundred miles to the Uncompahgre Valley near modern-day Delta. Here Robidoux found an ideal location for a fort, with plenty

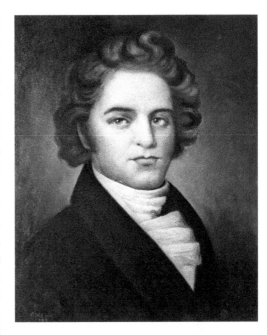

Portrait of Antoine Robidoux, the owner of Fort Uncompahgre. From an oil painting by Waldo Love. *Courtesy History Colorado (Scan #10049737).*

of grass, wood and water. The men constructed a log post along the south bank of the Gunnison River and dubbed it Fort Uncompahgre (a Ute word loosely translated as "red water"). Although no written records exist that describe its layout and size, Fort Uncompahgre probably included log and adobe shacks surrounded by picket posts.

Like most trading posts of the day, Fort Uncompahgre offered clothing, cooking utensils, blankets, sugar, coffee, tobacco, knives, whiskey and firearms. Although Mexico prohibited the sale of alcohol and guns to Indians, Robidoux thumbed his nose at the regulations. He was hundreds of miles from authorities, or any civilization whatsoever. Besides, the Utes were desperate for weapons to fight their well-armed enemies to the north, tribes that traded with the British.

Robidoux earned a hefty profit from Fort Uncompahgre, as well as another post he purchased in present-day Utah called Fort Uintah. Throughout the 1830s and into the 1840s, he earned himself the moniker "Kingpin of the Colorado River Fur Trade." But Robidoux didn't reinvest his profits in creating fine establishments for eastern gentlemen. In 1842, a Methodist

preacher found shelter at Fort Uintah and asked if he could join Robidoux on his next trip to New Mexico. While he waited for Robidoux to organize the mule train, the preacher wrote:

> *This place is equal to any I ever saw for wickedness and idleness…Some of these people at the Fort are fat and dirty, and idle and greasy.*[31]

The preacher also noted that Robidoux supplemented his business by engaging in the slave trade, a nefarious practice that was common in those days. Mexicans kept Indian slaves to work in the household or in the fields, and in turn, some Indian tribes captured Mexicans for slaves of their own. An adolescent boy or girl could be sold for $50 to $200 in New Mexico.

As their journey began, the preacher expressed his disgust at the delays caused by

> *the wickedness of the people, and the drunkenness and swearing, and the debauchery of the men among the Indian women. They would buy and sell them to one another…Mr. Rubedeau [sic] had collected several of the Indian squaws and young Indians to take to new Mexico…The Spaniards would buy them for wives…two of Rubedeau's squaws ran away and we had to wait two days till he could send back to the Fort for another squaw, for company for him.*[32]

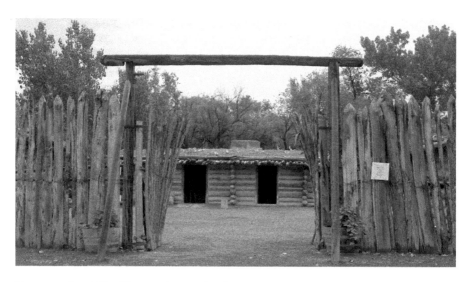

Reconstruction of Fort Uncompahgre at Confluence Park in Delta. *Photo by Sean Gallagher.*

By 1844, Robidoux's shady business practices caught up with him. One day at Fort Uncompahgre, he turned over the fort management to his employees and then abruptly rode off. No one knew where he had gone, but many suspected why he left. For years he had sold firearms to the Ute tribes and avoided punishment by bribing authorities or avoiding them altogether. Now the Mexican officials wanted to question him.

Around the time of Robidoux's disappearance, one hundred Southern Ute warriors rode into Santa Fe with guns and ammunition purchased at Fort Uncompahgre. The Utes were angry that Mexican farmers had settled their hunting grounds in the San Luis Valley and wanted to negotiate a treaty with the Mexican government. Within minutes of the meeting, an argument broke out among the Mexicans and Indians. Someone fired a shot, killing a Ute chief without provocation. Gunfire exploded all around, forcing the Utes to battle their way out of the city. Escaping north, they attacked farms and any Mexican citizens they could find on their way to Fort Uncompahgre.

At the Uncompahgre River, the Ute warriors spied two fort employees wading barefoot into the cool waters to check their beaver traps. A warrior took a shot at one, killing the man instantly. The other, Colario Cortez, ran downriver as lead balls zinged around him. Reaching the fort, Cortez discovered the bodies of his fellow employees strewn around the grounds. He found six dead and no sign of their women. Cortez made a frantic run for the mountains, without boots, a coat or a firearm. For the next two weeks, Cortez walked on bare feet to Taos, where he arrived nearly starved and frozen. He then choked out his story to Mexican authorities. He said that everyone at the fort was dead or captured, but the fort remained intact. Apparently, the Utes only wanted revenge on the Mexicans working there. They had no issue with Robidoux, nor did they disturb his goods.

After the attacks, Mexico blamed Robidoux for arming the Utes. They ordered his arrest, but no one knew where to find him. His wife, Carmel, may have known his whereabouts, but she had quietly shuttered their home in Santa Fe and slipped away. Eventually she met her husband in St. Joe, Missouri, a town founded by Antoine's older brother Joseph Robidoux. Robidoux then liquidated all their assets in Santa Fe, and by the autumn of 1845, the Kingpin of the Colorado River Fur Trade was no longer welcome in Mexican territory.

Fort Uncompahgre lay abandoned and never opened for trade again. Two years later, the Ute Indians burned the fort. In 1990, the City of Delta built a replica of Fort Uncompahgre in Confluence Park, two miles from its original location.

The World Is Coming with Him

Despite agreements made after the Texas Revolution in 1836, the Americans and Mexicans continued to dispute their borders for another ten years. Ultimately, their arguments escalated into war, a conflict that would change the landscape of the United States and Mexico.

In the summer of 1846, upward of 1,700 American soldiers marched toward Bent's Fort—raw recruits who were itching for a fight with Mexico. The force was called the Army of the West, a massive contingent that included two batteries of artillery, three squadrons of dragoons, one regiment of cavalry, two companies of infantry and a volunteer Mormon Battalion (a unique group of Mormon pilgrims and their families earning money for their journey to the Salt Lake Valley). The Army of the West was commanded by Colonel Stephen Watts Kearny, a seasoned officer with experience extending as far back as the War of 1812. Kearny had relatively little knowledge of the Southwest, and like Frémont before him, he needed reliable scouts. Back east, army officials found Antoine Robidoux and convinced the former fur trader to serve as a guide and interpreter. At age fifty-two, Robidoux was no longer a young man, but

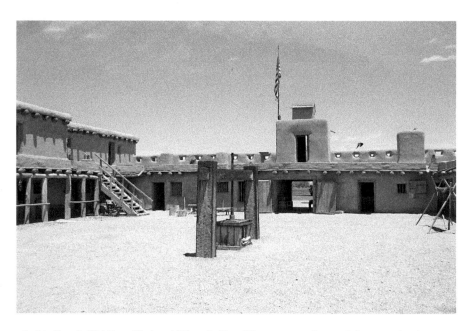

Inside Bent's Old Fort, National Historic Site. The room on the top left corner is where Susan Magoffin would have stayed. *Photo by Sean Gallagher.*

with his Santa Fe business gone, he needed to make a living and agreed to serve with Kearny.

The first detachment of Kearny's army arrived at Bent's Fort in July after suffering in the blistering heat of a treeless prairie. They demanded food, shelter and medical attention from fort employees. Within hours, soldiers purchased all the whiskey the store had to offer, and drunken brawls broke out among the men. One soldier drowned in the river, too inebriated to swim. As more detachments arrived, Bent's Fort was entirely overwhelmed. William and his brother George could host only a few officers inside. They turned away many others, telling them to pitch their tents along the river.

When a Santa Fe trader named Sam Magoffin entered the bustling fort, he begged William Bent to allow his pregnant wife to recuperate inside. Graciously, William cleared an upper-story room for Susan Magoffin while her servants brought in her furniture. Mrs. Magoffin kept a daily journal, describing her experiences and impressions of the fort. She said the rooms were spacious with windows, but the dirt floors required constant sprinkling of water to keep down the dust. Magoffin wrote, "Any water that may be left in the cup after drinking is unceremoniously tossed onto the floor."[33]

For a sheltered lady of eastern society, the activities of the post shocked Magoffin:

> *There is no place on Earth I believe where man lives and gambling in some form or other is not carried on. Here in the Fort, and who could have supposed such a thing, they have a regularly established billiard room! They have a regular race track. And I hear the cackling of chickens at such a rate some times I shall not be surprised to hear of a cock-pit.*[34]

Days later, Magoffin suffered a miscarriage. Adding to her heartbreak, an Indian woman in a room below gave birth to a healthy boy. Within half an hour, the new mother went to the river and bathed herself. Magoffin wrote, "Never could I have believed such a thing, if I had not been here... No doubt many ladies in civilized life are ruined by too careful treatments during child-birth..."[35]

As Magoffin lay in her room, more soldiers packed into the fort. Magoffin wrote, "The Fort is crowded to overflowing. Col. Kearny has arrived and it seems the world is coming with him."[36] Like Magoffin, the Indians were also stunned by the sheer number of soldiers. Their tents lined the river for miles. Their animals counted in the thousands. William Bent's son George

remembered their reaction, stating that "the Indians had never supposed there were as many men as this in the whole 'white tribe,' and they watched the passing of the troops in amazement."[37]

As the entire army assembled at the fort, Kearny sent negotiators to New Mexico asking for their surrender. They sent word back to Kearny that the governor, Manuel Armijo, had refused the terms. Kearny knew Armijo's untrained and unruly bunch of New Mexican volunteers would be no match for his army; once they saw his men march in, they would have no stomach for a fight. But Kearny also suspected the Mexicans might ambush his troops on Raton Pass, a possibility he couldn't risk. Kearny summoned William Bent, asking if he would lead a spy mission. At first, Bent laughed him off. The army had depleted his supplies, overrun his fort and caused him numerous headaches. He was in no mood to help Kearny further.

Adding to Bent's problems was Ceran's brother Marcellin. The St. Vrain booshway had suddenly appeared at Bent's Fort, afraid for his life and pleading for his brother Ceran to hide him there. Marcellin said he had accidentally killed an Indian in a wrestling match, and the tribe wanted retribution. Some folks questioned the validity of his story. Marcellin was small, only 115 pounds, and Indians were expert wrestlers. How could the slight Marcellin overpower an Arapaho man? (Decades later, an Arapaho chief named Friday would claim that Marcellin trapped a band of Arapaho inside the gates and turned the fort's guns on them. But historians agree that his story is implausible. A mass murder would surely have been told by more than just one man.) Ceran knew his brother had likely killed someone because soon after he arrived, an angry Arapaho warrior pushed his way through the soldiers and traders crowding the courtyard. He demanded to see Marcellin. Ceran turned the Arapaho away and then quietly slipped his brother out the fort gates. Marcellin was a nervous wreck, barely capable of rational thought. He wanted no more of frontier life, and no more of his Sioux wife and children, whom he had abandoned back at Fort St. Vrain.

With all this St. Vrain family drama, Kearny knew Bent was on edge. When Kearny approached him again, he promised ample compensation. The money softened Bent's prickly temper, and he agreed to lead a scouting party. With several frontiersmen at his side, Bent rode out of the gates with the American flag snapping in the dry, hot wind above them. Once they reached Raton Pass, they surprised a few ragged-looking Mexicans and took them prisoner. When Bent could find no other enemy spies, he led the group back to the fort. The Mexican captives rode tiny burros, which they guided

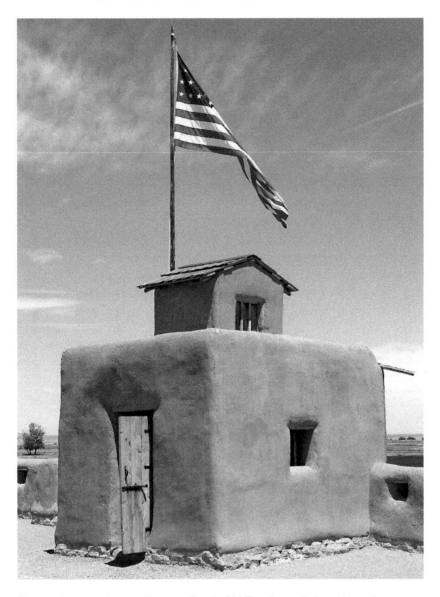

Flag waving over the guardhouse at Bent's Old Fort, located above the main gate. *Photo by Sean Gallagher.*

by hitting the animals' rumps with clubs. Later, Bent's son George would remember their ridiculous appearance at the fort:

> *When my father's men led these Mexican scouts into camp they were greeted with shouts of laughter. The big American dragoons on their fine big*

Missouri horses were too disgusted even to swear when they beheld the kind of enemies they had marched six hundred miles across desert plains and mountains to meet, and old Thomas Fitzpatrick, a huge, grim mountain man who hardly ever smiled, burst in roars of laughter every time he looked at the prisoners.

For his service, William would receive the honorary title of colonel, but he would have no more involvement with the war. Meanwhile, Kearny's confident troops rode out and rolled through New Mexico without ever firing a shot. In Santa Fe, the acting governor accepted Kearny's terms of surrender. Then Kearny climbed the roof of the governor's palace before an assembled crowd, with Antoine Robidoux scrambling up beside him. Kearny shouted that they must now swear allegiance to the United States and that they must not oppose American forces or they would suffer punishment. As Robidoux repeated the words in Spanish, he saw many of his old friends below. Their faces were grim.

When Kearny left New Mexico, he appointed Charles Bent as their new governor. With the city in Bent's capable hands and Colonel Sterling Price's reinforcements on the way, Kearny left with three hundred of his finest militia to California. Robidoux rode along as a guide but didn't know the trail to California well enough. By pure coincidence, Kearny met Kit Carson riding fast and furious from the west. He had been with Frémont in California yet again and now carried dispatches for officials in Washington. Kearny couldn't believe his luck. He needed a guide to San Diego, and here was Carson riding from that very direction. After a year with Frémont, Carson was exhausted and anxious to get home, but Kearny pressed him. Only Carson knew the way over the dry and brutal desert. Reluctantly, Carson gave his dispatches to another soldier and agreed to lead Kearny to San Diego.

By the time they neared the coast, the men lacked the energy to fight. In a misty rainstorm, Mexican volunteers and ranchers ambushed Kearny's men. Their waterlogged muskets jammed, forcing them into hand-to-hand combat with lances and swords. Carson was thrown from his horse on the first attack, tossing him safely away from the bloodiest fighting. Robidoux took a lance to his lower back and fell wounded. The men carried Robidoux to a ship in San Diego, where he recovered on the journey around Cape Horn and up to New Orleans. Robidoux returned to his family in St. Joe and then launched a new career guiding wagon trains and selling wares along the Oregon Trail. His injuries from the war made the long rides difficult, and Robidoux retired on a military pension in St. Joe. The wear and tear of the frontier finally crippled his aging body, taking his life at age sixty-five.

Ready to Wade in Mexican Blood

Kearny may have bowled over Santa Fe, but the New Mexicans and native Pueblos didn't plan to surrender just yet. They played along with the newly appointed governor Charles Bent, who promised them improved schools, roads and court systems. Those promises didn't sway them. The citizens also resented Colonel Price's volunteer troops, who caused havoc with their drunken and belligerent behavior. Despite the unrest in Santa Fe that winter, in 1847, Charles Bent badly wanted to spend time in Taos with his family. The gray-haired governor, now forty-seven years old, traveled north for home to enjoy a brief respite from his exhausting responsibilities.

Back on the Arkansas, his brother William shrugged off threats of a New Mexican uprising, deciding the rumors were just that—rumors. William left his brother George in charge of Bent's Fort and then traveled east to Big Timbers. On the spot where his old friend Yellow Wolf once said he should build a fort, William decided to open another post. Yellow Wolf had been correct. The location was perfect for trading with the numerous tribes who gathered there in winter. Near the river and in a grove of trees, Bent constructed log cabins that were divided into two rooms. It was peaceful in the cottonwoods, a relaxing break from fort activity, a place where his wives and children could visit with their extended family.

With Bent that winter was a new employee, Lewis Garrard, a seventeen-year-old boy who ventured west after reading Frémont's published reports of the Rocky Mountains. Although Garrard spent most of his time at Big Timbers, Bent occasionally sent him on errands to Bent's Fort. Garrard enjoyed his occasional stay in the miniature citadel, where he could eat at a table, sleep behind the safety of walls and listen to the gossip from Bent's slave, Charlotte Green. In the evenings, the fort inhabitants often gathered in the courtyard for music and dancing. The men quickly snatched up the few women at the fort for a spin, as Garrard described in his journal:

> And then the airs assumed by the fair ones—more particularly Charlotte, who took pattern from real life in the "States;" she acted her part to perfection. The grand center of attraction, the belle of the evening, she treated the suitors for "the pleasure of the next set," with becoming ease and suavity of manner. She knew her worth, and managed accordingly; and, when the favored gallant stood by her side, waiting for the rudely-scraped tune, from a screaking [sic] violin, satisfaction, joy, and triumph, over his rivals, were pictured on his radiant face.[38]

Drawing of a typical trapper during Colorado's fur-trade era. *Courtesy History Colorado (Scan #10028698).*

Back at Big Timbers, Garrard also admired the frontiersmen working as traders for Bent:

> *My companions were rough men—used to the hardships of a mountaineer's life—whose manners are blunt, and whose speech is rude...Yet these aliens*

from society, these strangers to the refinements of civilized life, who will tear off a bloody scalp with even grim smiles of satisfaction, are fine fellows, full of fun, and often kind and obliging.[39]

One morning at Big Timbers, Garrard and the others heard the approach of a Bent employee entering the village. It was Louis Simonds, who insisted on speaking with William Bent immediately. While someone fetched Bent, the traders invited Simonds to sit and share a meal. Through mouthfuls of buffalo meat, Simonds relayed his report to a gathering group of men. He told of a mass revolt in Taos. The New Mexicans and Pueblo Indians had stormed through the stores and homes of Americans, killing any man they could find. Finally the mob reached Governor Bent's home. Inside were his wife and children, along with Kit Carson's family, who were living there temporarily. In the early morning hours, the rebels scaled the walls and rushed into the courtyard. Charles Bent tried to stall by talking to them through the closed door, while the women and children frantically dug a hole at the back to escape into an adjoining house. Bent tried to offer them money, but they shouted him down. Lead balls exploded through the windows. Charles fell to the floor. From above, Pueblo Indians crashed through the roof, shooting arrows into his body. Before he was even dead, a Pueblo caught him by the hair and used a bowstring to scalp the governor. His wife shoved the children though the hole in the wall and then returned to her husband's side. They ignored her pleas for mercy, continuing to mutilate Bent's body.

As Simonds finished his story, the mountain men clutched their knives and vowed revenge. Unnoticed, William Bent sidled up to the group. The men looked up and then quickly averted their eyes. William motioned for Simonds to join him outside, where they could talk privately. Everyone pitied William Bent, Garrard said. They all loved and respected his brother Charles.

The next morning, Bent prepared to leave for the big fort upstream. The Cheyenne chiefs at Big Timbers offered to send warriors to attack Taos in vengeance for killing Charles. Bent wouldn't allow it. This was a white man's war, he said. Bent rode off, taking Garrard with him. Up the Arkansas, Bent remained taciturn for the forty-mile journey, scarcely stopping for ten minutes to water the animals. When they arrived at the fort gates, scores of frontiersmen met them, itching for retribution. Garrard described the scene:

There was much excitement in regard to the massacre, some expecting a Mexican army to appear on the hill across the river; others, strutting inside the high and secure fort walls, gasconaded and looked fierce enough to stare a mad "buffler" [buffalo] out of countenance, declaring themselves ready to wade up to their necks in Mexican blood.[40]

At his fort, Bent met an army captain stationed there. Bent argued with him, insisting his troops should leave for New Mexico. But the captain received no dispatches from Colonel Price in Santa Fe and wouldn't move without orders. Angry, Bent declared he wouldn't wait for the rebels to come calling at Bent's Fort; no, he would find the rebels. He gathered the frontiersmen together, asking for volunteers to fight. Everyone offered his services. Although they numbered only twenty-three men including Garrard, they could surprise and attack any Mexicans coming their way. Bent was ready to ride with them, but the army captain convinced him to stay behind and defend Bent's Fort if necessary.

As the frontiersmen rode south, Bent received a message from El Pueblo. An old friend and businessman, John Albert, had fled from a murderous mob in Taos and walked the entire 170 miles north, eventually stumbling on the Mormon Battalion camped just south of El Pueblo. At the time of the Taos uprising, the Mormon recruits and their families had built cabins on the south side of the river, dubbing their settlement Fort Independence. The rough log homes were chinked with mud and situated in a neat row, forming a street that led to a house of worship. Here, upward of 275 people settled in for the winter, until the men received further orders or could continue in the spring to Salt Lake.

When Bent arrived at El Pueblo, the American employees rounded up fifteen Mexican workers and marched them in front of Bent. They vowed to kill the Mexicans if he just gave the word, but Bent knew those fort employees could not have participated in the Taos uprising. Bent told the mountaineers to release the Mexicans. He then met with the recovering John Albert, who was cared for by the Mormon women at Fort Independence. Albert told Bent all he knew about the revolt. When Albert finished, Bent could do nothing more but return to his fort downriver.

While Bent waited for news from New Mexico, Ceran St. Vrain organized sixty-five volunteers in Santa Fe. St. Vrain's men joined Price's three hundred regulars, who effectively scattered the rebels. A determined Colonel Price then marched into Taos. They laid siege to the village, where terrified citizens took refuge in a church. Not swayed by the sanctity of the church,

Trader's store inside the reconstructed post at the El Pueblo History Museum. *Photo by Sean Gallagher.*

Price bombarded it with cannon fire. When all was done, 150 Taos villagers lay dead. Price gathered captured rebels and immediately put them on trial for murder and treason. The jury, composed entirely of Americans and their sympathizers, sentenced the men to hang. Garrard was appalled by the proceedings, later writing: "Justice! out upon the word, when its distorted meaning is the warrant for murdering those who defend to the last their country and their homes."[41]

The war with Mexico continued for another year until the Americans emerged victorious. In the Treaty of Guadalupe Hidalgo, Mexico ceded lands north of the Rio Grande and west of the Rockies. Americans finally achieved their Manifest Destiny, gaining all the land from the mountains to the Pacific Ocean. With the Mexican rebellion squelched, business returned to normal at the Arkansas trading posts. The U.S. Army saw no further need for a military presence in the area. The remainder of the Mormon Battalion marched for Salt Lake in the spring of 1847, abandoning the village of Fort Independence.

THE ONLY BENT BROTHER LEFT

After losing his brother Charles, William Bent kept himself busy. He turned his attentions to building a ranch on the Purgatoire River, fertile ground where he could graze animals and raise crops. Bent rode to the location, instructed his employees to dig irrigation ditches, cabins and corrals. While he worked, Owl Woman went into labor with their fourth child. Someone sent for William as sisters Island and Yellow Woman stayed by her side. In agony, Owl Woman pushed and struggled to bring her baby into the world, but just as little Julia drew her first breath, Owl Woman drew her last. Bent arrived too late. The family had already placed Owl Woman's remains on a scaffold in the branches of a cottonwood tree, as was their tradition. In his grief, Bent turned to Yellow Woman and Island for help in raising the children. The fiercely independent Yellow Woman had little interest in the children, even her own son Charley. It was Island who took on the burden of caring for the Bent clan.

With Charles gone, the financial management of Bent's Fort fell to Ceran St. Vrain. After the war, St. Vrain returned east to conclude some business matters. The battles in New Mexico had exhausted him, and he no longer wanted a partnership in Bent's Fort. He wrote letters to the government with a proposal. The Southwest needed a permanent military installation, he wrote. Charles Bent had proved that fact, unfortunately, with his life. Then, without consulting William, St. Vrain offered to sell their fort to the army. The structure was perfectly suited for a military post.

While St. Vrain waited for a reply, Bent worried about the Comanche and Apache raiding settlements in the south. He consulted with the newly appointed Indian agent, Tom Fitzpatrick, for advice on the problem. They wanted to do right by the Indians and allow them to continue the only life they knew—the roaming life of hunters—but now that the land south of the Arkansas River belonged to the United States, American settlers would soon elbow out the Indians. Bent and Fitzpatrick believed the Indians could effectively claim their land by adapting to farming, but they also knew they would never relinquish their nomadic ways.

Bent wanted to transfer their business to Fort St. Vrain, away from the warring tribes. William's brother George agreed to haul trade supplies north, but while preparing to leave, George took to his bed with a bad cough and fever. Despite the herbs and poultices available at the fort, George slowly expired. As they laid George in a grave next to Robert, William set aside plans for moving north.

Not long after George died, two companies of dragoons rode into Bent's Fort. They were under the command of Lieutenant Colonel William

Gilpin, a veteran of the recent war who had also served in Frémont's 1843 expedition. Bent knew Gilpin. He had been at the fort before. The man was odd, often spouting grandiose ideas of Manifest Destiny. But he was also a trusted military veteran who could help protect southwest traders from Indian attacks. Bent offered to provide Gilpin with fresh supplies, even though the army had all too often taken advantage of his hospitality. While Gilpin made himself comfortable, St. Vrain arrived from the east. Less generous than his partner, St. Vrain refused Gilpin any supplies until they received payment from the government. Coolly, Gilpin and his men rode west, doing business at El Pueblo instead.

With Gilpin gone, St. Vrain took William aside for a serious talk. Profits were dwindling. The territory was still unstable. St. Vrain told Bent he had offered the fort to the army. Annoyed, Bent refused to sell. The two men argued, finally dissolving their partnership completely. William's son George remembered his father's solitude and grief, stating, "My father was now the only one of the Bent brothers left in the mountains, and he ran the business alone."[42]

FRÉMONT'S CHRISTMAS CAMP

In a blustery snowstorm of October 1848, Frémont once again passed through the gates of Bent's Fort. This time he led a privately funded expedition with over thirty-five botanists, geologists and geographers. His object was to map a route over the Rockies, a traversable path for a transcontinental railroad to California. Although several routes were proposed, Frémont favored a southern line over the Rockies.

At the fort, Frémont looked for a scout to guide him over the mountains. The fort employees laughed. Heavy snows had already fallen; the journey was suicide. Frémont once again asked for Kit Carson, but Carson refused to risk a mid-winter trek. Frémont wouldn't listen to the naysayers. Hoping to uphold his reputation as the great "Pathfinder," he would prove that the thirty-eighth parallel could be traversed in the worst of circumstances.

Two mountain men, Dick Wootton and Old Bill Williams, finally agreed to accompany Frémont. Off they rode against everyone's advice. In a blinding snowstorm, the exploration party turned south into the Sangre de Cristo Mountains. After some of their mules dropped dead, Wootton advised them to turn back. Bull-headed Frémont insisted they continue, and Wootton wisely turned back toward the safety of his ranch. Now with only Williams as

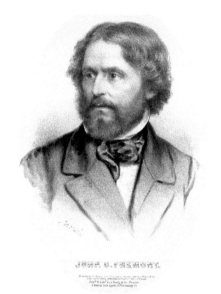

Portrait of John C. Frémont, whose expedition teams often resupplied at Colorado forts. *Courtesy Library of Congress, Prints & Photographs Division.*

a guide, he and Frémont argued over which direction to take over the San Juans. Not listening to Williams, Frémont determined their course. The men slogged through waist-deep snow and whiteouts, eventually ascending Mesa Mountain. More mules died from hunger and from falling down cliffs. Much like Zebulon Pike in years before, the wayward Frémont despaired at which way to turn.

On Christmas Day, they made camp on a mountainside. They named the site Camp Hope, but it would later be known as Frémont's Christmas Camp. Splitting his group, Frémont sent a detachment downriver and continued with another party on a different path south. Others stayed behind with the scientific instruments. Without food, they filled their bellies by eating bits of leather and blankets. When several men died of starvation, the others survived by eating their dead companions.

As Frémont made his way south, a Ute Indian discovered him and guided his group safely out of the mountains. In Taos, Wootton came across the party and helped Frémont to Kit Carson's home. Wootton carried the frostbitten and delirious Frémont into bed, where Carson's wife, Josefa, nursed him back to health. Other members of Frémont's party straggled into Taos as well, leaving ten men dead in the mountains.

Carson could scarcely believe Frémont's story. He would always defend this man he admired, later telling his biographer:

> *The hardships through which we passed I find it impossible to describe and the credit to which he deserves I am incapable to do him justice in writing…I can never forget his treatment of me while in his employ and how cheerfully he suffered with his men when undergoing the severest of hardships.*[43]

GOLD AND THE CIVIL WAR
(1849-1864)

I n 1849, eager gold seekers flooded the trails leading to the Pacific Ocean. The wagons rolled by in staggering numbers. At first the Plains Indians were curious about these people and often stopped to trade with them. After one such meeting, an entire band of Cheyenne suffered from severe cramps and aching pain. The California-bound pilgrims brought cholera, a bacterial infection of the intestines. The sickened Cheyenne returned to their villages, and before long, the "big cramps" spread through their entire tribe. In a few short months, half their people lay dead.

In a panic, Bent's wives put the children on ponies and travois, quickly making their way from the Indian village to Bent's Fort. When William Bent returned from a business trip in Westport, he found his family healthy but shaken. He barricaded everyone inside, in hopes they would be spared from the quickly spreading disease. But outside the walls, angry Cheyenne yelled taunts at Bent and his employees, blaming the white men for killing their people. With his old Cheyenne friends turning against him, Bent decided it was time to leave the Arkansas fort. Up north, he could conduct business until the scare was over and send employees to trade with travelers on the Oregon Trail. Bent's traders could also encourage migrators to swing down to Fort St. Vrain for supplies, fresh animals and repairs on their wagons.

As Bent made plans to transfer business to Fort St. Vrain, the Plains Indians fought back against the Americans on the trails. The United States government knew it must control the Indian uprisings or the western territories could never be settled. In 1859, another gold discovery in the Rocky Mountains convinced the government that more military

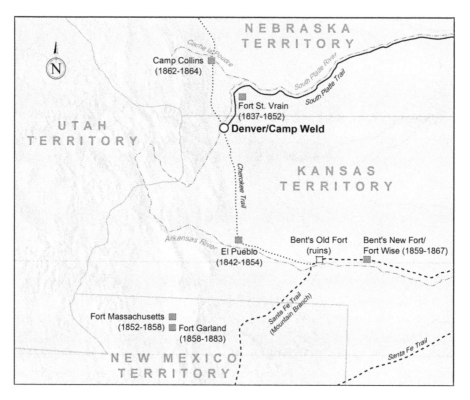

Territories that composed future Colorado in 1849–64, showing forts during the Civil War and gold rush era. *Map by Sean Gallagher.*

protection was needed. The army selected sites for frontier outposts to protect white travelers, and soon forts would dot the western trails into Colorado.

WE HEARD AN EXPLOSION

Leaving his adobe castle behind, Bent drove his wagons by El Pueblo and then up past the ghostly remains of Fort Lupton, Fort Jackson and Fort Vasquez. Along the way, his son George remembered seeing Indian villages stricken by cholera:

> *On the Platte whole camps could be seen deserted with the tepees full of dead bodies, men, women and children. The Sioux and Cheyennes, who*

were nearest to the road, were the hardest hit...Our tribe suffered very heavy loss; half of the tribe died, some old people say. [44]

At Fort St. Vrain, Bent met a handful of Mexican employees and white traders still working there, all in good health. But the decaying state of the fort probably angered him. After Marcellin St. Vrain left, the fort was in dire need of repairs. As one traveler described Fort St. Vrain that year:

> *The walls of unbaked bricks were cracked from top to bottom. Our horses recoiled in terror from the neglected entrance, where the heavy gates were torn from their hinges and flung down. The area within was overgrown with weeds, and the long ranges of apartments once occupied by the motley concourse of traders, Canadians, and squaws, were now miserably dilapidated.* [45]

Bent hired laborers to repair the damaged bricks and then invited the Arapaho and Sioux to camp around its walls. He had one last problem, though. What to do about Marcellin's abandoned wife? Spotted Fawn, or "Red," as she was known around the fort, clung to desperate hopes that her husband would return. Every day she climbed a hill along the river, keeping vigilance for any sign of a man riding her way. The employees of the fort shook their heads. The poor girl, they said; he's never coming back. The St. Vrain family had quietly committed Marcellin to a sanatorium back in St. Louis.

A wagon teamster named William Bransford befriended the dejected woman. Bransford was a loyal Bent employee, who had led the rag-tag frontiersmen into New Mexico after Charles was murdered. Everyone liked the young man. They couldn't stop ribbing Bransford for the time he tried to halt a charging buffalo by stepping directly in its path and shooting at its forehead. The lead ball bounced off the buffalo's head, and as the beast kept barreling toward him, the terrified Bransford dove to the side. Perhaps Red laughed at that story too. She allowed the good-natured Bransford to spend time with her, but she continued to climb the hill each day, watching the eastern horizon.

Someone wrote to Ceran St. Vrain about Red, and before long, he sent for his sister-in-law. Red and the children traveled to Mora, New Mexico, where St. Vrain operated a gristmill and store. He tried to convince Red that her husband would never return. She wouldn't listen. When Red was comfortably settled in Mora, Bransford rode down to visit them. He carried a piece of paper and showed it to Red. It was Marcellin's death certificate.

Portrait of "Red" St. Vrain, wife of Marcellin St. Vrain, in 1886. *Courtesy Denver Public Library Western History Collection, X-31899.*

Bransford and St. Vrain crafted the fake certificate to end Red's hopes. Marcellin had checked out of the sanatorium, married a St. Louis girl and gotten his life back together. The white lie may have worked if Marcellin hadn't appeared like a ghost in Mora one day, demanding to see his sons. He wanted them educated in St. Louis schools, he said, and insisted they come back with him. No one stopped Marcellin as he lifted his two boys onto the saddle in front of him and then rode away. After he left, Red finally knew their marriage was over. In the coming months, she would accept Bransford's marriage proposal.

Back at Fort St. Vrain, Bent was relieved to learn that Bransford and Red had settled down together, but he had new concerns. His northern trade

thrived for only a short time. Although the Indians had agreed to stop attacking travelers in exchange for land and annuities, the traffic on the Oregon Trail dwindled anyway. The California gold rush was over. With the loss of business, Bent decided to move back to the Arkansas in 1852. He packed his wagons once again and abandoned the last trading post on the South Platte. Later, farmers would move into the rich bottomland surrounding the old fort, eventually plowing under its foundation.

When Bent reached his adobe castle on the Arkansas, it looked more like an ancient ruin than a trading post. Bent strolled through the rooms. With the loss of his brothers and his beloved wife, too many sad memories were baked into those mud walls. The government had wanted to purchase the post, but its offer was stingy when Bent considered all the years he hosted armies and expeditions. Now the fort was too dilapidated to repair. Bent determined what he could salvage and then ordered everything stripped and placed in wagons. He led his employees and family east for several miles, making camp along a creek. His son George, then nine years old, remembered the next day as they prepared to move to Big Timbers:

> *In the morning the train pulled out down the river before daylight and my father rode back to the fort alone. My stepmother told us children that he was going to blow up the fort. Soon we heard an explosion, and then my father rode back and joined us.*[46]

Not wanting the army or anyone else to reuse his fort, Bent had filled the rooms with gunpowder and obliterated the inner chambers. Yet the sturdy walls withheld the blasts, and for many years the hallowed-out castle would shelter immigrants and gold seekers. It would later serve as a stage stop and post office before falling into ruins once again. In 1960, Bent's Old Fort was designated a National Historic Landmark. It was reconstructed on its original foundation in 1976.

SERVING AN UNGRATEFUL MAN

At Big Timbers, Bent was dissatisfied with his post along the low riverbanks. In the U-shaped collection of log and adobe shacks, his trade goods grew moldy in damp rooms infested with rats. He needed a better location, away from the water. In 1853, Bent hired stonecutters to construct a new fort

on the bluffs above the river. Although his plans were for a smaller post than his original adobe castle, the stone structure would be an impressive sight up on the hill, approachable from only one direction. It would include twelve rooms around a courtyard and a good-sized warehouse. The walls would extend sixteen feet high, with small cannons at each rooftop corner, menacingly pointed down at whoever approached.

As his workers cut stone from the cliffs, Bent saw a familiar face coming into his trading post. It was John Frémont, on another journey. After the disastrous fourth expedition, Frémont organized a fifth and final mission to California. He had previously failed to prove that the Rockies were traversable in winter but remained adamant that he could find a safe route for a transcontinental railroad. When he arrived, Frémont asked for fresh mules and supplies. Bent agreed to help Frémont but advised him not to venture farther. It was already November and the mountains would be snow-packed. But Frémont planned to move ahead anyway.

With Frémont that year was a camp helper, James Milligan, who kept a detailed diary of their trip. From the start, Frémont and Milligan butted heads. After an argument with Frémont, Milligan wrote:

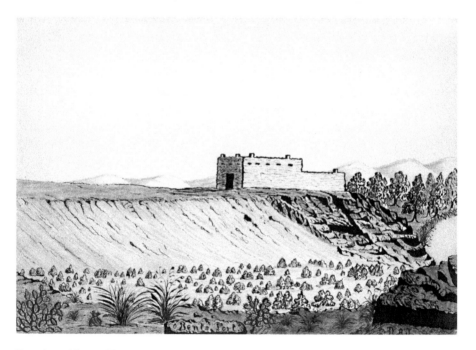

Drawing of Bent's New Fort, located on a bluff above the Arkansas River. *Courtesy Library of Congress, Prints & Photographs Division.*

> *Had a talk with Col. Fremont in regard to his domineering and selfish*
> *manners. Made up my mind to proceed no farther with him as circumstances*
> *have occurred which are exceedingly trying upon my feelings, and all I*
> *require is an opportunity to express them...The Col informed me this*
> *morning that he intended making other arrangements for me. As yet I am*
> *entirely ignorant of what they are but anything is better than serving an*
> *ungrateful man.*[47]

Frémont ordered Milligan to remain behind with foot-sore animals while the rest of the twenty-one-man expedition rode away on mules supplied by Bent. Relieved to see Frémont go, Milligan surveyed the forty-mile stretch of cottonwoods that the Indians called Big Timbers. The lodges of Cheyenne and Arapaho were sprinkled throughout the woods, while Bent's stone fort rose on the cliffs above. Milligan wondered how to occupy his time until Bent agreed to hire him for odd jobs. Bent allowed him to sleep in a log cabin, but before long, Milligan became disillusioned with the living arrangements. He was appalled by the rats and lice in the cramped quarters, plus the Indians in the nearby village were always beating their drums and giving him a headache. Still, the Indian camp held carnal pleasures for Milligan. He enjoyed the company of the Indian women, although he didn't realize that when he took a Cheyenne woman as a "wife," he was responsible for her entire family as well. Milligan wrote:

> *Went to Bob Tail Bear's Lodge to drink my own Coffee with the Squaws.*
> *Mrs. Bear offered to trade me her niece but* [I] *declined having one squaw*
> *already to support and all her family. I find married life among the*
> *Chayennes* [sic] *quite expensive enough with one wife.*[48]

By the spring of 1854, Milligan realized Frémont had abandoned him there. As Bent prepared to journey east with the season's hides, Milligan asked to join him. That year, Bent decided to take his youngest sons, George and Charley, to be educated in a Westport school with their older siblings Robert and Mary. During the journey, Milligan expressed his harsh opinion of George and Charley when they trapped a buffalo calf. He wrote, "Bent's Semi-Barbarian Children killed it in mere wantonness while my back was turned."[49]

Bent's younger children knew nothing of the white man's world. In Westport, Bent took them to his old friend Albert Boone, who agreed to be their guardian while the boys attended school. The adjustment was difficult

for George and Charley. They wouldn't see their beloved Cheyenne relatives for another decade, not until the whites and the Indians battled for the plains. As they grew into adulthood, the Bent children were each faced with a difficult decision. Would they side with the whites or with the Indians?

BESPATTERED WITH THE BLOOD OF VICTIMS

In 1854, the original builders of El Pueblo had taken over fort management once again. They repaired the roofs and adobe walls, hoping to attract trade. When finished, they put Benito Sandoval in charge of over a dozen employees and their families. Sandoval was the brother of Teresita, who had married El Pueblo founder Alexander Barclay years before.

Late in December, Dick Wootton rode inside the gates looking for Sandoval. While he was out hunting, Wootton had spied a Ute chief named Tierra Blanca leading a war party. He advised the fort inhabitants to keep vigilance. Wootton reminded them that the Muache Ute and Jicarrila Apache were blaming the whites for smallpox infestations and getting revenge by attacking settlements. Sandoval shrugged him off. He knew Tierra Blanca and assured Wootton they had nothing to fear.

After Wootton left, the El Pueblo families prepared for a Christmas Eve feast. The courtyard was crowded with women cooking in hornos (bee hive–shaped ovens), children running about with dogs and men playing cards. During the day, Sandoval saw Tierra Blanca approach the gates. He walked over to chat with the chief. During the course of their banter, Blanca bragged about his shooting skills and challenged Sandoval to a friendly match of marksmanship outside. Sandoval agreed and grabbed his firearm. As the pair took turns shooting at targets, Blanca's warriors rode in one by one, and before long, they surrounded Sandoval. Still, he didn't worry. Feeling generous on Christmas Eve, he invited Blanca and the others to share their dinner.

Inside the fort, Sandoval introduced the Ute warriors to his employees and their families and then offered them cups of Taos Lightning. The Utes refrained from gulping down the whiskey, taking only dainty sips while their hosts tossed back cup after cup. Chief Blanca smiled and waited. When the employees staggered and slurred, Blanca gave the signal. The warriors drew their weapons—guns, knives and lances. Before Sandoval could reach for his gun, the Ute warriors shot him down. Then they turned their weapons on every other man in sight. Two women escaped to the river, while a lone fort

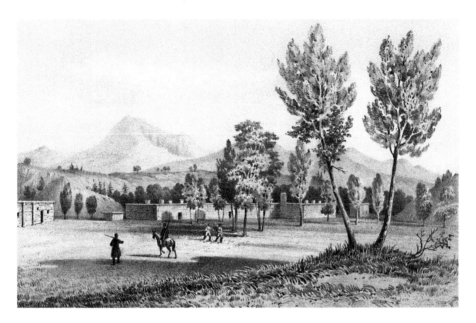

Fort Massachusetts near Mount Blanca in 1855, the first military installation in Colorado. From a sketch by R.H. Kern. *Courtesy History Colorado (Scan #10027250).*

employee managed to run for help after getting shot in the mouth. When all was done, fifteen men lay in pools of blood on the hard-packed earth. The Utes spared the women and children, including two of Sandoval's sons and a young wife of an employee, Chipeta Miera. The Utes knew the value of women and children and captured them for the Southwest slave trade.

News of the massacre reached Fort Union, New Mexico Territory. Rumors also circulated that Fort LeDuc in the Wet Mountains had been attacked. In February 1855, the commander of the military district in New Mexico, General John Garland, sent Colonel Thomas Fauntleroy with four hundred troops to punish Chief Blanca's band. Along with him were Kit Carson, acting as scout, and Ceran St. Vrain, leading the companies of volunteers. Near present-day Del Norte, Fauntleroy picked up a trail and followed them north. They chased Blanca's warriors into the hills, but the Ute managed to lose them.

The soldiers recuperated at the nearest post, a newly built fort in the San Luis Valley named for the commander's home state of Massachusetts. Three years before, in 1852, upward of 120 soldiers had built Fort Massachusetts at the base of Mount Blanca, where steep cliffs surrounded a grassy valley on three sides. The men had chopped and chinked logs, constructing a

rectangular post that measured 270 by 320 feet on the west bank of Ute Creek. Around a courtyard, the buildings included quarters for soldiers and officers, a hospital, bakery, kitchen, laundry and blacksmith shop. Outside the post gates, a spacious corral penned their animals and a sutler's store offered extra provisions to the soldiers. (The sutler, John Francisco, later opened a trading post near the Spanish Peaks called Fort Francisco.)

At Fort Massachusetts, Fauntleroy planned further campaigns against the Ute Indians. Throughout the entire spring and into the summer, they attacked Ute villages, prompting the chiefs to negotiate for peace. In Santa Fe, Governor Merriwether and the new Indian agent, Kit Carson, granted the Ute one thousand square miles west of the Rio Grande and north of La Jara Creek for reservation land. In the deal, each side turned over prisoners to the other. One of the Sandoval boys was given up after negotiations, but the other had been traded to the Navajo as a peon (he was recovered years later). Chipeta, the female captive from El Pueblo, had been killed by the Ute.

After the massacre, El Pueblo was never occupied again. A decade later, Dick Wootton said:

> *The massacre which had occurred in 1854 had operated to keep people away from there, not only because they feared another outbreak but because they had a sort of superstitious dread of being near the old fort. The walls of the old adobe building had been stained and bespattered with the blood of the victims of the slaughter and there were stories about it being haunted, which made even some of the mountain men timid about stopping over night in it when they passed that way.*[50]

Over the years, the city of Pueblo laid its streets over the fort's foundation. The site was later excavated and can be viewed from a street corner next to the El Pueblo History Museum.

EXTINCTION IS IMMINENT

In the fall of 1858, two gold prospectors rode into Bent's new fort. The Russell brothers carried a bag of gold dust, enough to raise eyebrows among the employees there. Where did they find it? Was there more? William "Green" Russell said more could be found in the tributaries leading into the South

Platte River, much more, and then continued east to procure equipment and supplies for their return trip. Just as the Russells rode out, a group of speculators rode in. The eastern cities already buzzed with gold fever, they said, and they planned to make a hefty profit by establishing town charters and selling tracts of land. With the group were Edward (Ned) Wynkoop and other future founders of Front Range towns.

Following the businessmen, tens of thousands of eager Americans saddled their mules and packed their wagons. To the south, they flooded Bent's new fort as they stopped for supplies. To the north, more migrators plodded over the trail, using the remains of Fort St. Vrain, Fort Vasquez and Fort Lupton as campsites. Even Louis Vasquez joined the rush. Now in his sixties, Vasquez left Westport to help finance a grocery store with his nephew Pike Vasquez in the new city of Denver. By 1859, towns had mushroomed all along the eastern edge of the mountains, including Laporte, Golden, Boulder, Colorado City and Pueblo.

The Indians grimly watched this steady stream of gold seekers who scared off the buffalo and tramped over land promised to them in treaties. With the tensions rising again between Indians and whites, the government asked William Bent if he would serve as its Indian agent after Fitzpatrick's death. Bent already had many business responsibilities but accepted the appointment anyway. If not him, someone else might step in, someone who could never understand the Plains Indians as he did. Bent met with the Cheyenne and Arapaho. He tried to convince them to take up farming so they could claim the land before whites moved in. Initially they agreed, respecting Bent's opinion; but later, the Cheyenne men vowed never to plow fields. Manual labor was woman's work, they grumbled; men were hunters and fighters.

Bent also rode south to meet the Comanche and Kiowa, tribes that were increasingly crowded out of Texas and moving farther north. Not only did the Comanche and Kiowa refuse to farm, but they also promised to kill all whites who tried to settle their hunting grounds. Frustrated, Bent detailed the impossible situation in a government report:

> *A smothered passion for revenge agitates these Indians, perpetually fomented by the failure of food, the encircling encroachments of the white population, and the exasperating sense of decay and impending extinction with which they are surrounded...A desperate war of starvation and extinction is imminent and inevitable, unless prompt measure shall prevent it.*[51]

When Bent arrived back at Big Timbers, the army caused more headaches for him. Once again, soldiers flooded into his stone fort and took advantage of his hospitality. Now sorry that he built the expensive structure, Bent offered it for sale. The army liked the location, sitting high on a defensible bluff. It also felt satisfied with the comfortable quarters and airtight storerooms. But when Bent said he would sell for $12,000, no less, the army choked. It could build its own military installation for less money. Instead, it offered to lease the stone fort. Bent agreed, later emptying his storeroom and moving to his ranch on the Purgatoire River.

While Bent moved out, the army moved in. It renamed the structure Fort Fauntleroy, in honor of the commander who battled Ute Indians. Then, in the summer of 1860, the War Department sent Major John Sedgwick to supervise the construction of barracks and other buildings below the cliffs. Sedgwick was not pleased with the assignment. He had led his men in a successful campaign against the Kiowa, and now they must build a fort on the desolate prairie? Despite his protests, the army insisted he build a larger post.

Sedgwick's two hundred cavalrymen laid down their arms and took up trowels. To build the fort, they first decided on a sod construction. They tried plowing the earth for sod bricks, but a summer drought had baked the ground hard. They couldn't overturn it. Instead, the men pried stones from the nearby bluffs and cut logs from the cottonwood groves. Without enough tools to go around, Sedgwick had to improvise. He told his soldiers to use old stovepipes, camp kettles and broken wagon wheels for implements.

Drawing of Fort Wise and Bent's New Fort, from a painting by Robert Lindneux. *Courtesy History Colorado (Scan #10031783).*

They also constructed a hospital. Injuries were common on the frontier, along with diseases related to poor nutrition. The soldier's diet consisted mainly of beans, bacon and hardtack, with a little fresh meat whenever a hunter could procure it. Canned goods were not widely available in those years. Unless the soldiers knew where to find edible roots and berries as the Native Americans did, they suffered from malnutrition. Sedgwick's men had not eaten fruits or vegetables for six months, and many of them suffered from scurvy.

Before winter set in, the troops completed a square mile of stone huts and corrals, situated around a central parade ground. Although the barracks were comfortable, the buildings lacked windows and doors. The men hung canvas over the openings, barely enough covering to keep out the cold, while the hard-packed earth served as a floor below their aching feet. The army named the post Fort Wise to flatter the governor of Virginia, Henry Wise. With Southern states beginning to secede, the army hoped Virginia would stay in the Union. (The ploy didn't work; Virginia seceded a few months later.)

During fort construction, the commissioner of Indian affairs asked William Bent to ride around the territory to round up Indian tribes for treaty talks, but Bent's health was failing him. No longer could he manage the horseback rides over the territory, or even a journey by wagon that jostled his insides. At age fifty-two, Bent resigned his appointment as Indian agent. In his place, he recommended his old friend Albert Boone, the man who had served as guardian for his children in Westport.

When Boone arrived to begin his new duties, he hoped to find a solution that satisfied both white settlers and the Indians. He negotiated the Treaty of Fort Wise, in which the Cheyenne and Arapaho ceded their hunting grounds for a reservation along the Arkansas, between Sand Creek and the Purgatoire River; but with only a few tribes agreeing to the terms, the treaty was practically meaningless. Indians still roamed the land as white settlers continued flooding into the area. Hoping to claim the land for their own, white citizens appealed to Congress for territorial status. In February 1861, Congress granted their request. They carved out land from Nebraska, Kansas and New Mexico territories to create the territory of Colorado (forming its present-day boundaries).

In the meantime, Bent built his final trading post at his Purgatoire ranch, a log stockade much like his first picket post near Pueblo. The fifteen-foot logs formed a perimeter around cabins, facing a central court. His oldest son Robert lived with him, and soon his daughter Mary would follow with her husband from Missouri. Both Island and Yellow Woman had left him, but

Bent hoped his sons George and Charley would join him there when they completed school back east.

George and Charley had other plans, though. When the Southern states began seceding from the Union, the Bent boys left school in Missouri to join the rebellion. George enlisted when he turned eighteen, soon followed by younger brother Charley, who lied about his age. Confederate service proved to be a short career for George and even shorter for Charley. Charley never made it past training camp. Officers guessed his age, sending the boyish youth packing. A year later, George was captured by Union forces. He sat in a Union jail in St. Louis until a family friend secured his release as a favor to his father.

Brother Robert took George home with the Bent caravan. When they passed the old stone fort on the hill, George saw the new military post of Fort Wise, looking like a small city below the cliffs, with scores of Union soldiers garrisoned there. George did not want to stop; instead, he avoided the bluecoats and kept riding to his father's ranch on the Purgatoire. His father still managed a good trade in buffalo robes, as well as lucrative contracts hauling goods to the army. George didn't like his father's dealing with the Union or his attitude that the Indians must adapt to farming. Before long, George would ride north looking for his brother Charley, who had joined a band of Cheyenne with his mother, Yellow Woman, and sister Julia.

THE CITIZEN MUST BE A SOLDIER

In the spring of 1861, the new governor of Colorado stepped off the stagecoach in Denver. The crowds greeted Governor William Gilpin with cheers and saluted him with cannon fire. A well-educated graduate of West Point, Gilpin had traveled with Frémont, served in the army and explored a vast amount of land west of the Mississippi. After his arrival in Denver, Gilpin stood on a hotel balcony to address the citizens below. Appointed by newly elected president Abraham Lincoln, Gilpin vowed his loyalty to preserve the Union, stating, "May she never become divided or her glory less dim."[52] A third of Denver's citizens were Southern sympathizers, certainly not pleased with Gilpin's declaration.

Gilpin faced a daunting pile of work. He would need to create court systems, a body of government and a volunteer militia to protect Colorado from potential Confederate invasion. To lead the militia, he selected men

like county sheriff Ned Wynkoop to serve as officers, along with respected citizens Samuel Tappan and the Methodist minister John Chivington. Tappan rode around the territory recruiting unemployed miners and unruly frontiersmen, taking any able man for the First Colorado Volunteers. Until a camp could be constructed to garrison it, the militia occupied camps in Golden and Central City and quarters on Larimer Street in Denver.

In southern Colorado, more miners and settlers volunteered for the militia as well. Meeting in Cañon City, they mustered into service as the Second Colorado Infantry and marched over the mountains to join Union soldiers at the new Fort Garland. In 1858, Fort Massachusetts had closed after an army inspector had reported on its numerous deficiencies, mainly involving its isolated location. General John Garland selected a new site six miles to the south. It was on the trail between Sangre de Cristo Pass and La Veta Pass, with an unobstructed view in all directions. The layout of Fort Garland included a quadrangle of single-story adobe buildings around a parade ground with space between buildings at each corner. All doors and windows faced inward, allowing the thick outside walls to serve as a defensive barrier.

The raw recruits arrived at Fort Garland wearing tattered boots and ragged clothes. They reportedly owned only one decent coat between them, which was shared by each man standing guard duty. When their commander noticed the guard always wearing the same coat, he reprimanded the recruits. He wanted to know if the same man stood guard every night. One soldier told him, "No, be jabbers, but the same coat kivers [covers] the whole company now."[53]

By the autumn of 1861, Gilpin had raised two regiments. To arm them, he issued government drafts to pay local merchants and settlers for any guns and ammunition they could spare. His drafts were unauthorized by the federal government, but no matter. He would worry about paying the citizens later. In his address to the first Colorado legislature, Gilpin rallied the people for support:

> *The military organization of our people demands your prompt action. The citizen must be also a soldier and armed. The system of civil society is never safe from revolution and the shocks of sudden conspiracies, unless associated with and fortified by an equally vigorous discipline of its physical power.*[54]

Meanwhile, the Southern-born regulars garrisoned at Fort Wise and Fort Garland made plans for a hasty exit. One by one, they resigned their commissions or asked for leave so they could return to their home states in the South. If leave wasn't granted, they outright deserted their posts. After

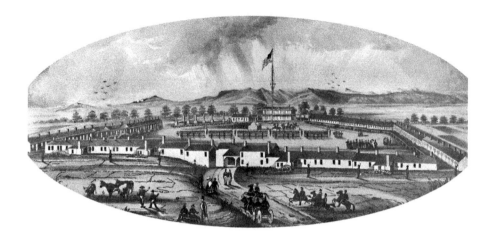

Camp Weld outside Denver in 1862, from a sketch by J.E. Dillingham. *Courtesy History Colorado (Scan #10035272).*

the disruption of departures, the remaining officers were all ordered to take an oath of allegiance to the Union.

Up in Denver, Gilpin's militia had other problems. Southern sympathizers accumulated weapons and fired potshots at the volunteers as they marched down the streets. To stop the attacks, Captain Tappan ordered his troops around a Denver saloon where the Southerners gathered and then pointed a cannon through the front door. Their leader surrendered and was put under arrest. After the remaining agitators fled the city, Tappan marched his company southeast to reinforce Fort Wise, whose forces were depleted after Southern-born regulars left to join the Confederacy.

To garrison the Denver militia, Gilpin made plans for a thirty-acre military camp two miles from the city. He named it Camp Weld to honor the secretary of the Colorado Territory, Lewis Weld, who oversaw the post's construction. Although only designated a "camp," the post was an impressive installation. It included brick-and-lumber buildings that sat around a square parade ground, including officers' quarters, barracks, cavalry quarters and stables, a guardhouse and hospital. In the middle of the parade ground, a brick magazine held the post's ammunition, secured behind iron doors. Each of the barracks accommodated twenty-five men, with mess rooms and huge fireplaces at either end. By living standards of the day, the rooms were quite comfortable. The officers enjoyed even finer quarters in cottage-like homes with covered porches. Near the front gates, the regimental headquarters included an upper

balcony where visiting dignitaries could watch the company drills and parades.

Camp Weld soon became a hub for Denver socialites with regular formal dinners and dress balls hosted by the officers and the post band supplying the musical entertainment. The commanding officer, Colonel John Slough, gave the *Rocky Mountain News* editors a tour of the post. They were impressed by how Slough had transformed the barren land into a bustling post of one thousand men. One editor gushed at the final touches:

> *Running entirely around the enclosure, and twenty-five feet from the buildings, a top-rail fence is being constructed, affording a most commodious and beautiful roadway for vehicles and equestrians, without interfering with drills and parades. As Camp Weld has already become a favorite place of resort for our citizens, and will prove still more attractive when finished, fenced and whitewashed, this last arrangement is a most admirable one.* [55]

Although the citizens enjoyed watching the camp activity, the volunteer soldiers were less thrilled with their duties. These recruits hoped for a fight with Southern rebels but found themselves engaged in manual labor and tedious drills instead. Echoing the sentiments of many Colorado soldiers, Private Romine Ostrander wrote in his diary:

> *This life is the dullest life that I ever led and I believe it as dull as any life that a man can lead. Monotony! Monotony! Monotony! Every day just like the one that preceeds* [sic] *it.* [56]

Ostrander also had less than complimentary words for his commanders:

> *We had a company drill this morning, and battallion* [sic] *drill this afternoon: during which we made…our usual awkward appearance in consequince* [sic] *of our officers being such egrigious* [sic] *blockheads, as to give the wrong commands, and throw us into confusion.* [57]

Without adequate training, the soldiers became an insolent, unruly bunch. They spat profanities at the officers, stole goods from local stores and lounged in Denver gambling dens. By Christmas, the soldiers had gone without pay for four months and lived on stringy beef and coarse bread. To fill their bellies for a Christmas Day feast, they belligerently pilfered eggs,

vegetables and poultry from local farms and then broke into a local saloon to grab barrels of whiskey.

Down on the Arkansas, Fort Wise suffered its own problems. One of the Colorado volunteers, Ovando Hollister, wrote about the fort's inadequate accommodations when he joined Tappan's company:

> *Blankets, arms and clothing were thrown in the dirt because there was no other place to put them, and we found that our experience in cooking and eating, with no conveniences but fire and fingers, extensive as it was, had still left us mere tyros in the art. Discovering that we must help ourselves out of these hog-pens or remain in them, we divided into messes, occupied some deserted rooms, stole and cut up wagon-boxes for bunks and tables, bought a set of dishes and some cooking utensils and lived to suit ourselves while we remained there.*[58]

Despite the conditions, Hollister still praised Fort Wise as "the pleasantest of all the government Posts near the mountains, from Laramie to El Paso."[59]

Along with soldiers, laundresses and officers' wives also lived at Fort Wise. Many of the Indians camped nearby had never seen a white woman before. The strange, modestly clothed women piqued their curiosity. The wife of the company quartermaster, Mrs. Byron Sanford, complained about the Indians peering in her windows as if she were on display for their amusement:

> *My windows are high up from the ground but they manage to darken them with their dirty visages. I have taken my journal to write, that seems to amuse them. One squaw has lifted her pappoose [sic] high up above the rest to attract my attention…an old "buck" has come and is perched on the shoulders of a squaw, peeking in at the topmost pane. He is making all sorts of signs and grimaces, wants to get inside, but I am impervious and turn my back on the scene, hoping they will soon take the hint and leave.*[60]

While Colorado soldiers settled into Camp Weld, Fort Wise and Fort Garland, Confederate troops were on the move from Texas. Led by General Henry Hopkins Sibley, upward of 2,600 Texans rolled through New Mexico territory, where they handily conquered Albuquerque and Santa Fe in the winter of 1862. When Gilpin received word of the invasion, he ordered Colorado troops to make a swift and punishing march into New Mexico. They must intercept Sibley's forces before they could enter Colorado and claim its rich gold fields for a Confederate prize.

In record time, the troops from Camp Weld and Fort Wise converged on the territorial border (near Trinidad), while troops from Fort Garland made their way down the San Luis Valley. Traveling twenty to forty miles a day through snowstorms, the regiments reached Fort Union, New Mexico, where they joined forces with Federal soldiers. The combined troops then marched down the Santa Fe Trail and surprised the Confederates in a narrow canyon. The hero of the day was the fiery preacher John Chivington, who charged at the approaching enemy without a single bullet grazing him. Days later, Chivington led an attack on a Confederate supply train. His forces destroyed the wagons, forcing Sibley to retreat for Texas.

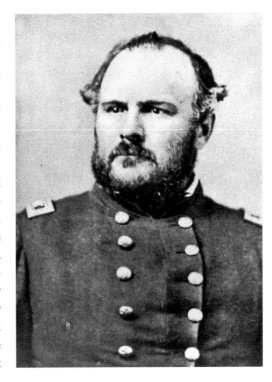

Portrait of Colonel John Chivington between 1860 and 1870. *Courtesy Denver Public Library Western History Collection, Z-128.*

After the victory in New Mexico, Chivington was promoted to colonel and became the highest-ranking officer in the territory. Tappan returned to command Fort Wise, where Union officials decided a name change was in order. Forsaking the rebel governor of Virginia, they renamed the post Fort Lyon to honor Brigadier General Nathaniel Lyon, the first Union general to die in the Civil War. Tappan was later sent to command the isolated outpost of Fort Garland. Although the command should have been a quiet assignment, brutal outlaws known as the "Bloody Espinosas" had been terrorizing the area by randomly murdering innocent people. Tappan hired frontiersmen Tom Tobin to track them down, and in a matter of days, Tobin returned to Tappan's office with two severed heads of the Espinosas in flour sacks.

Back in Denver, the returning militia proudly marched through the streets and back to Camp Weld. The citizens, who had once complained

of the soldiers' stealing and boozing, now greeted them with patriotic cheers. But Governor Gilpin received none of the gratitude. The drafts he issued to local merchants and bankers were rejected by the U.S. Treasury, striking a blow to the Denver economy. He had written drafts totaling $375,000, a staggering amount of money in those days. Outraged, the citizens screamed that Gilpin stiffed them. Likewise, the Treasury Department sent Gilpin angry dispatches. Washington summoned him to account for his actions, and although his prompt call to arms may have saved Colorado from a Confederate invasion, Gilpin was removed from office.

MYSTERIOUS ATTRACTION ABOUT HER

With no more threats of Confederate invasion, the new governor of Colorado, John Evans, turned his attention to protecting the migration trails from Indian attacks. In the summer of 1862, the Overland Trail was established along the South Platte River to carry both passengers and mail into Denver and other towns. The stage line followed the river to Latham (present-day Greeley), where it forked into two roads. The main line continued up the Poudre River to the town site of Laporte (now a suburb of Fort Collins) while another branch cut down to Denver. Before that time, no forts protected the northern Colorado trails.

In July 1862, the Ninth Kansas Cavalry moved into Laporte and established a temporary post of rude cabins and pitched tents. It named the camp for Lieutenant Colonel William Collins, who had originally protected the road in the months before. Shortly thereafter, the First Colorado Cavalry commanded by Captain David Hardy moved in to replace it while another company was dispatched downriver to establish a post it called Camp Sanborn (near present-day Greeley). With relatively few Indian raids in the area, Captain Hardy spent much of his time listening to soldiers bicker about their assignments, fruitlessly chasing horse thieves and tracking down a local agent of the stage line named Jack Slade, who had turned into a drunken outlaw.

While Hardy was in command in June 1863, a local settler walked into Camp Collins. The settler was worried about a Ute girl, captured by the Arapaho. He said that in the middle of the night, he awoke abruptly to find Arapaho men crowded into his cabin. They wanted to make a

Portrait of a Ute woman thought to be Chief Ouray's sister "Susan." *Courtesy History Colorado (Scan #10048403).*

trade for his hat and looking glass, insisting he come with them. The settler followed the Indians to their camp, where an Arapaho pointed at a thirteen-year-old and said, "Swap." Disgusted, the man refused the girl and decided to report the incident to Camp Collins. He told Hardy to

keep an eye out for her, in hopes the soldiers would rescue her from the Arapaho men.

Later, Hardy's men found the girl with an Arapaho band and negotiated for her release. (Although the newspapers reported that the soldiers charged in to save her as the Arapaho were about to burn her at the stake, that romanticized version of the story is highly suspect.) They called her "Susan" and brought her back to Camp Collins, where she stayed with a local family. Although the family treated her well, Susan desperately wanted to return to her own people. One night, while her foster family attended a dance in Laporte, Susan slipped out of the house and ran for the mountains. A rancher happened by with a wagon, hid Susan beneath his load of cabbages and took her into the mountains. From there, Susan made her way to the mining town of Empire. A reporter for the *Commonwealth* newspaper wrote that there was "a mysterious attraction about her that suited many of the youth of that pious village."[61] Eventually, Susan found her way back to her brother, Chief Ouray, an important chief among the Uncompahgre Ute tribe. She forever remembered the kindness the whites showed her and hoped to one day repay the favor.

Back at Camp Collins, the garrison never faced an enemy greater than Mother Nature. In June 1864, a flash flood pounded through the camp like a battering ram. Ohio soldiers garrisoned there barely escaped the raging waters with their lives. The camp was destroyed. Instead of rebuilding, the army scouted for a new location on higher ground and away from the

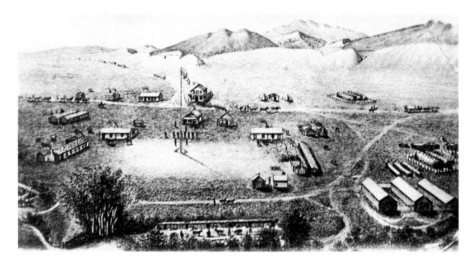

Drawing of Fort Collins in 1865. *Courtesy History Colorado (Scan #10049734).*

tempting saloons in Laporte. Four miles downstream, it constructed the post of Fort Collins. The fort grounds sat on a nine-hundred-foot-wide strip of land between the river and the Denver Road (later Jefferson Street) and were surrounded by a 6,100-acre military reservation. Unlike early Colorado posts, Fort Collins was an open fort, without stockade walls to protect it. Log cabins and barracks surrounded a central parade ground on three sides, with the river flanking the fourth. When the major work was complete in late 1864, the post included barracks, officers' quarters, a brick bakery, storerooms, stables and a guardhouse. The ninety- by twenty-foot log barracks housed two companies, each with its own mess hall. Quarters for the officers extended thirty-six feet by thirty-three feet with their own kitchens, fenced backyards and outhouses in back. Past the fort grounds was a "Citizen's Row," which included a two-story sutler store called "Old Grout" where the men could purchase extra provisions such as tobacco, coffee and sweets. Another officers' mess was also constructed nearby, known as "Auntie Stone's cabin," which still survives today.

Before long, the soldiers from Fort Collins would respond to a growing Indian war. Although the Arapaho camped around the area were friendly, displaced easterners swarmed into the territory after the Civil War and aggravated the Plains Indians. These soldiers would struggle to keep peace in an increasingly volatile environment.

WAR ON THE PLAINS
(1864–1870)

At the close of the Civil War, the Plains Indians knew the whites would return. Many had left to serve in the conflict, but now these "hat-wearers" would flood the trails again, scaring off buffalo, bringing their diseases. When the whites built homes and stage stations on the plains, some young warriors raided isolated settlements, deftly disappearing into the prairie whenever soldiers appeared on the scene. By the summer of 1864, warring bands terrorized the trails leading into Denver, even though the old chieftains advised them to stop. In decades before, some had witnessed the impressive forces marching with Dodge and Kearny as they entered Bent's Fort, all armed with sabers and guns. No, they couldn't win a war against this huge white tribe.

Ignoring the advice of their elders, some warriors escalated the attacks. Just southeast of Denver, settlers came upon the burned remains of the Hungate family's ranch house. They first found the body of the mother, stabbed and scalped. Her four-year-old daughter and infant lay nearby with their throats cut and heads nearly severed from their necks. The father, also scalped and mutilated, was found up the creek. The neighbors brought the bodies into Denver, placing the disfigured corpses side-by-side in open coffins for everyone to view. The horrific sight touched off rage and fear.

Preparing for the worst, citizens organized home guards and constructed forts for their own protection. In Huntsville (present-day Larkspur), local ranchers built a log stockade they dubbed Fort Lincoln to serve as a defense against Indians. On a bluff above Pueblo, townsfolk erected a tower with rifle ports for easy sighting and shooting. In Colorado City (Colorado Springs),

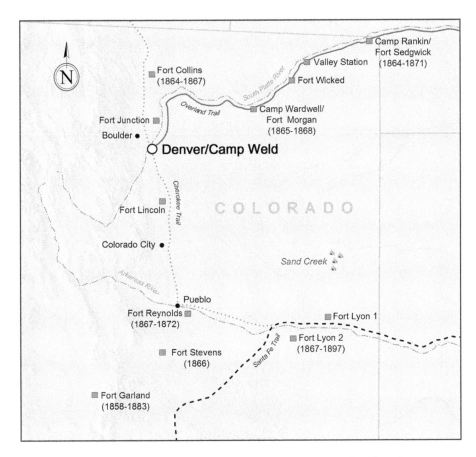

Colorado Territory during the Indian wars of 1864 to 1870. *Map by Sean Gallagher.*

they stacked logs around a prominent hotel and barricaded the women and children inside at night. In the Boulder and St. Vrain Valleys, the farmers stacked sod for Fort Junction at the confluence of Boulder and St. Vrain Creeks while others erected Fort Chambers near Boulder. From behind the safety of walls, the citizens watched small bands of Indians riding through the territory. Some ran off their stock, but others wondered why the whites felt compelled to build these defenses.

In Denver and down the Front Range, Colonel Chivington recruited volunteers for the Third Colorado Cavalry, a one-hundred-day assignment with a singular mission: to seek out all hostiles and kill them. His actions would touch off a bloody war on the plains, where the frontier forts would be used as staging points and also as targets of Indian retaliation.

No Right to Be Called a Battle

During the Civil War, the Colorado plains were blissfully quiet. The soldiers at Fort Lyon occasionally chased Indians, horse thieves and a rogue band of Confederate soldiers called the "Reynolds Gang," but mainly they busied themselves with mundane drills and fatigue duties. Some women at the fort organized choirs and theatrical clubs for the soldiers to fill the extra hours. In turn, the troops hosted mock battles on the parade grounds, as the women cheered from the barracks' rooftops. The stage agent's wife, Julia Lambert, enjoyed her time at Fort Lyon. She wrote in her diary how she admired the officers, especially the fort commander, Major Ned Wynkoop, and his close friend Captain Silas Soule—both handsome and charismatic young men.

Lambert also witnessed the plight of the Indians camped around the fort. Many looked starved, badly needing the government annuities promised to them. Unfortunately, their respected Indian agent Albert Boone had been replaced with the unsympathetic Samuel Colley. At first, Colley distributed the goods at Fort Lyon in an orderly fashion. He would unload everything in a pile—blankets, kettles, knives, coffee, flour, bacon, dried apples, sugar, rice and beans. Around the goods, the young braves sat in a circle to receive the first pick. Behind them were the old men, women and children sitting in another circle. Lambert described how the agent's wife liked to tease the Indian women by taking out her false teeth. Lambert wrote: "You may imagine their surprise. They gabbled earnestly together, then taking hold of their own teeth tried to get them out."[62]

Lambert disliked the Colley family. They would steal from the Indians' annuities, she wrote, often keeping valuable items for themselves and selling them to white citizens or soldiers for a tidy profit. Lambert wrote how Mrs. Colley stored boxes of goods in her quarters and sold cloth to the officers' wives. She helped herself to dried apples and flour from the agent's warehouse, employed a soldier to bake pies and then sold them for twenty-five cents each.

Without the supplies due to them and their hunting grounds diminished, the Cheyenne and Arapaho tribes grew desperate. A fierce warrior society called the Dog Soldiers decided to fight back, sometimes cruelly and brutally. As the white settlers returned after the Civil War, the Dog Soldiers and other bands camped in a large village near the northeastern tip of Colorado, using it as a home base after raiding the Oregon Trail. George Bent, now twenty-one, also settled there with members of his Cheyenne family. When Dog Soldiers brought captive white women and children into the village, George

felt conflicted. No longer were they simply stealing horses and supplies, but now they were killing and kidnapping innocent youths as well. George pitied the captives. He saw the open, infected wounds all over the body of a teenage girl. He asked his stepmother, Island, to help. Island, who had left his father and returned to her Cheyenne people, did the best she could to nurse the girl back to health.

A chief in the village, Black Kettle, summoned George to his lodge one evening. He was concerned about the rash actions of the Dog Soldiers, fearing that the white soldiers would punish the entire village for what the warriors had done. In hopes of securing peace with the whites, Black Kettle traded with the Dog Soldiers for the white captives. He then asked George to write a letter to Fort Lyon. Black Kettle expressed his desire for peace and their intent to hand over their white prisoners. George volunteered to deliver the letter, but Black Kettle worried the Union soldiers might shoot him. Instead, he sent the aging chief and medicine man named One Eye, a friend of the Bent family who was known around Fort Lyon as a peaceable man. Surely, no one would shoot old One Eye.

At Fort Lyon, One Eye slowly approached the grounds. He waved a white flag with one hand and the letter in the other. The soldier on patrol was ordered to shoot all Indians on sight but couldn't put a lead ball in the old man. He brought One Eye to Major Wynkoop, who listened to what One Eye had to say. One Eye told him that white captives were in their camp and they wanted to trade them in exchange for peace talks. Wynkoop mulled it over. It could be a trap, or the old man could be sincere. In either case, Wynkoop felt compelled to rescue the white women and children.

Riding out from Fort Lyon, over one hundred men followed Wynkoop and One Eye on a long trek into the prairie. As they disappeared over the hills, some Fort Lyon inhabitants said Wynkoop was foolish, while others admired his courage. A week later, Wynkoop and his men galloped over a ridge and through the parade grounds. Wynkoop held a small girl wrapped in his coat, while beside him two young boys and a teenage girl rode on ponies. Everyone was astonished. Not only did Wynkoop avoid a possible ambush, but he had also successfully negotiated with the Indians to release the white women and children.

The women of the fort volunteered to care for the freed captives. Captain Soule brought the teenager, Laura Roper, to Julia Lambert for care. Roper wore the same dress from the day she was captured, just rags when she came into Lambert's home. Roper told Lambert her story of survival, how she witnessed the murders and mutilation of her friends before the Dog

Soldiers carried her off. A warrior had tied her hands behind her back and taunted her by slapping a bloody scalp lock in her face. The blood dried in her nostrils, and after four days in the hot sun, maggots hatched inside her nose and crawled all over her face. Even worse were the beatings and rapes. Lambert shivered at the tales, wondering how the girl had survived.

Once the freed captives were ready to travel, Wynkoop and Soule escorted them to Denver. Along with the group were seven chiefs from Black Kettle's village. Wynkoop promised they could talk with Governor Evans, even though he had no authority to arrange such a meeting. Once the chiefs assembled at Camp Weld, the council with Evans did not go well. Black Kettle tried to negotiate for peace, but Evans used the meeting to gather information about the tribes, their raids and their whereabouts. Alongside him, Chivington lectured the Indians and told them to surrender at Fort Lyon. As George Bent described the talks:

> *The chiefs remained puzzled by what Chivington had said and could not make out clearly what his intentions were. The truth probably was that he had already laid his plans…so in his talk he said nothing to alarm the chiefs or to disturb their belief that peace was soon to be concluded.*[63]

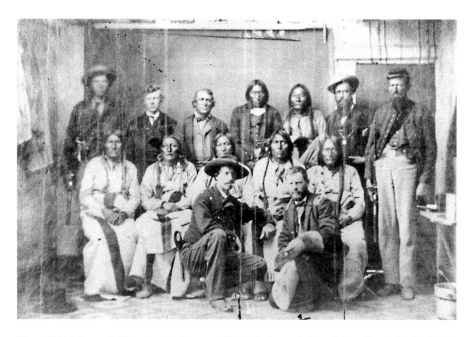

Camp Weld Council. Kneeling in front are Ned Wynkoop (left) and Silas Soule (right). Black Kettle is behind Wynkoop. *Courtesy Denver Public Library Western History Collection, X-32079.*

While Wynkoop returned with the chiefs to Fort Lyon, Chivington determined how he would lead a campaign against them. He led the Third Colorado Cavalry down the Front Range and then east along the Arkansas River. He knew Indians camped somewhere near Fort Lyon, as Wynkoop had reported, but Chivington didn't know how to find them. He needed a guide. Stealthily, Chivington and an advance guard approached William Bent's ranch, surrounded it and confronted the Bent family. Chivington leveled his gun at Bent's oldest son, Robert, and demanded that he saddle a horse and lead him to the Indian village. Petrified for his family's safety, Robert agreed to ride with the colonel. Possibly Chivington wouldn't attack a peaceful village with families, an Indian camp where his younger siblings George, Charley and Julia all lived.

Chivington left soldiers behind to guard the Bent ranch, ensuring that no one would escape to warn the Indians. Then the Third Colorado rode quietly into Fort Lyon and surrounded the post. By then, Wynkoop had been relieved of his Fort Lyon command and had just left for Fort Riley, Kansas. Still stationed at the fort, Captain Soule learned of Chivington's plans to attack the innocent village at Sand Creek. He went into a rage and vowed not to participate. But Chivington threatened to hang him, and Soule was forced to mount up with his company that evening. Leading the way was Robert Bent, probably sick to his stomach. With a gun to his head, Robert had little choice but to comply with Chivington's orders.

As the Third Colorado rode down on the Sand Creek village, Wynkoop's stagecoach traveled east. Its driver stopped to exchange gossip with another coach coming their way. Inside the other coach was Julia Lambert. She had been visiting family back east and was now returning to Fort Lyon. Wynkoop updated her on the Camp Weld talks before the coaches drove their separate ways. The next evening, Lambert's coach stopped along the river to camp for the night. While Lambert settled inside the coach to sleep, she was startled by sounds of splashing water from the river and the muffled voices of Indians. She peeked through the coach curtains, discovering the ghostly sight of Indian men, women and children wading through the icy water—all half-naked, injured and shaken.

Assuming Indians were on the warpath, the coach driver hastily moved out at sunrise, urgently wanting to reach the safety of Fort Lyon. Along the way, their coach met Chivington and a detachment of his Third Colorado Cavalry. They were chasing down the Indians, looking for stragglers who escaped. Chivington bragged how he had killed the savages as punishment for their constant raiding and outrages. His battle was an important victory

for white settlers, he declared. Lambert dropped her head in disgust, later writing, "It has no right to be called a battle."[64]

When Lambert arrived back at Fort Lyon, she heard a much different story from Captain Soule. It was a massacre, he said. He could do nothing to stop it. While his own company holstered their weapons and moved away, the other soldiers surprised the quiet village at dawn. The Indians scrambled in a state of half dress. Some armed themselves and fought back. Others ran for cover while small children screamed at their feet. Lambert wrote:

> *One young squaw pleading of a soldier to save her life, was stabbed to the heart by another who feared the first might show mercy, and this they were under orders not to do. Little children's throats were cut, babies were thrown into feed boxes on the back end of the wagons and later left by the roadside to die. Other things occurred which are unfit for publication.*[65]

During the slaughter, Robert Bent watched helplessly and worried for his siblings. Fortunately, his brother Charley was taken prisoner and wasn't hurt. But he knew nothing of George or his sister Julia. Perhaps they escaped. Perhaps they lay among the dead. When the battle was over, Robert searched for them. Among the bodies, he found One Eye, the old medicine man who had bravely approached Fort Lyon with the white flag. He also found Yellow Wolf, the eighty-five-year-old chief who was a life-long friend of his father. Sadly, Robert would carry the news back to the Bent ranch.

For another month, the Bent family wondered about George and Julia. They would not know their fate until a lone rider trotted into the ranch. Dressed as an Indian, George slid from his horse and greeted his father. He had been shot in the hip, but his injury was healing. He said Julia was safe, living in the north country with the survivors. In turn, Robert told him that Charley had survived but was crazed in his desire for vengeance. Their nineteen-year-old brother had ridden off to join the Dog Soldiers. George boiled with the same fury. He told his father that he could never live with the whites again, not after this. When his wounds fully healed, George joined Charley and the tribes regrouping along the borders of Colorado and Kansas. In the coming weeks, they would plot their revenge.

CLOSE AND DESPERATE FIGHT

Along the South Platte River, the isolated stage stations and frontier posts would soon pay the price for Chivington's actions. After Chivington's commission expired and the Sand Creek investigations were underway, the Colorado military fell under the leadership of Colonel Thomas Moonlight. With the Third Colorado mustering out of service, Moonlight formed the First Regiment of the Colorado Mounted Militia, including six companies of sixty men each. These volunteers joined the U.S. regulars stationed at Fort Collins and other camps along the Overland Trail. But with vulnerable stage stations dotting the road to Julesburg, every ten to fifteen miles for a two-hundred-mile stretch, the increased forces were still spread thin. Permanent military installations were needed.

In the fall of 1864, just months before the Sand Creek massacre, the Iowa Volunteer Cavalry had already moved into Julesburg. Leading the company was Captain Nickolas O'Brien, who was charged with building a fort under impossible circumstances. For miles around, he found nothing but undulating prairie grass. For cook fires, the soldiers lit stacks of dried buffalo dung. For sleeping quarters, they pitched tents around the Julesburg stage station, temporarily calling it the Post at Julesburg. But autumn nights were frigid on the prairie, with winds whipping viciously against their canvas tents. To keep warm, the men dug pits and pulled canvas over the top, where they slept underground as if lying in their own graves.

At age twenty-five, O'Brien was an energetic and loquacious officer, not one to sit on his

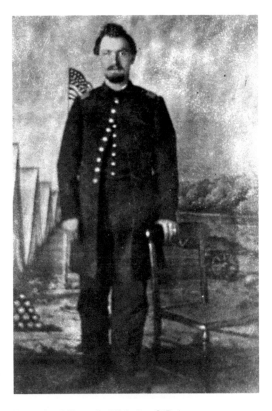

Portrait of Captain Nickolas O'Brien, commanding officer at Camp Rankin, 1862. *Courtesy History Colorado (Scan #10049738).*

hands. Before winter, O'Brien moved quickly on constructing a new fort. First, he purchased a two-room sod ranch as the main post headquarters. Then the men plowed and pulled thick sod from the earth, using it as bricks for stables and barracks. For a defensive wall, they stacked the sod five feet high around the 240- by 360-foot camp, with raised bastions at two corners. Inside the walls, the quarters and stables faced a parade ground. They initially used blankets to cover windows and doors until glass could be sent from back east. They named the post Camp Rankin, for an assistant adjutant general named John Rankin.

The Iowa unit patrolled the Overland Trail east from Julesburg. To the west, patrol duties fell under the Colorado militia. The Colorado soldiers used the Junction stage station (future Fort Morgan) as their main base, naming it Camp Tyler in honor of the Tyler Rangers who had protected the road in previous years. By winter 1864–65, detachments of Colorado militia spread up and down the trail, manning every stage station from Fort Collins in the west to Camp Rankin in the east.

One January morning at Camp Rankin, Captain O'Brien awoke with a start. A westbound stagecoach barreled into his post. The driver, shouting that Indians had chased him down, demanded a military escort. The camp guards found no Indians in sight and wondered if maybe the driver suffered from a vivid imagination or too much whiskey. O'Brien turned the driver away, telling him to wait at the Julesburg station until he could gather enough men to investigate. Fewer than forty men were garrisoned at camp that day; the other fifty were out patrolling the trail.

O'Brien ordered all available men to saddle their horses and ride out. Leading the detail east, O'Brien discovered a grisly sight along the road. They found an overturned wagon, with its teamsters dead and mutilated. The frightened stage driver had been correct; Indians were on the warpath. As O'Brien and the soldiers searched for the culprits, they spied several Indians riding toward the hills. Immediately the captain ordered the charge. As the cavalry neared the hills, the war-painted Indians turned to face them, taunting the soldiers by whooping and shaking their lances. At that moment, O'Brien realized his grave mistake. It was a trap. Those few Indians would not have faced down his forty soldiers unless more warriors hid behind the hills. O'Brien halted his men, ordering a retreat. As they turned their horses, they heard the blood-curdling cries of a thousand warriors behind them. O'Brien later wrote in his report:

> *Here a close and desperate fight took place and we were about to get the party, but discovering that the enemy were reinforced by an overwhelming*

force, hundreds on our front and right, a retreat was ordered. The enemy had a line four miles forward on the bluff and about four hundred a little southeast of the post.[66]

The Indians cut off fourteen soldiers from the group while O'Brien and the remaining men battled their way back to Camp Rankin. George

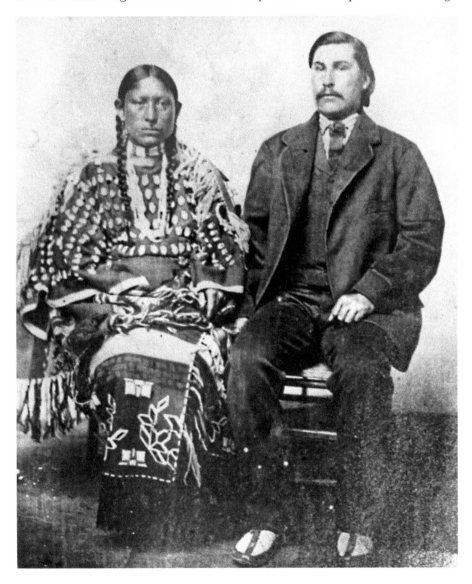

George Bent and wife Magpie (Black Kettle's niece). Kansas, 1867. *Courtesy History Colorado (Scan #10025735).*

Bent was among the warriors, all striking with their lances and shooting with rusty guns. After they surrounded and killed the fourteen bluecoats, George and his companions moved down to Julesburg. Other Indians had already attacked the town, chasing off the whites or killing them. George stepped inside the stage station, where he found breakfast laid out for stage passengers. For the first time in months, he sat down at a table to enjoy a meal. As he ate, he heard the booms of cannon fire from the fort, the shells falling short. George and the warriors took their time looting the station for supplies before disappearing into the sand hills.

From Camp Rankin, O'Brien had fired the cannons at the Indians. He held his post but could do little for those soldiers and citizens who didn't reach the safety of its walls. All morning, they were surrounded by a thousand warriors. When finally the Indians rode out and O'Brien emerged from the fort, he found a third of his company and five civilians dead on the prairie. Days later, O'Brien was ordered east to pursue the Indians. But the Indians had moved south, taking cover behind the hills. The young warriors, emboldened with their recent victory, celebrated and planned their next attack. Their next targets were the isolated stage stations farther upriver.

After the attack on Camp Rankin, the Colorado militia increased their patrols along the road. When eastbound wagons and coaches rolled into the stage station at Camp Tyler, soldiers forced them to wait until enough men gathered for a larger train. By mid-January, one hundred wagons had stopped at the station, enough to brave the journey. With every man armed and seventy-five soldiers guarding them, the big train slowly crawled east. They made their way toward another post the army established at the Valley stage station (future Sterling) and then continued on to Camp Rankin, where another detail would escort them out of Colorado. All that week, the Indians repeatedly swooped down on them from the hills. But the soldiers and citizens were ready, each time repelling them with their superior firearms. Frank Root, the manager of the Latham stage station (near present-day Greeley), wrote about the panic that year:

> *Wild rumors of Indian depredations continued to reach us almost daily—sometimes the reports were so thick that they came every few hours—recounting the brutalities being committed by the hostiles down the Platte east of Latham. Some of the stories told almost made the blood run cold...I never before experienced such feelings, and trust I never shall again.*[67]

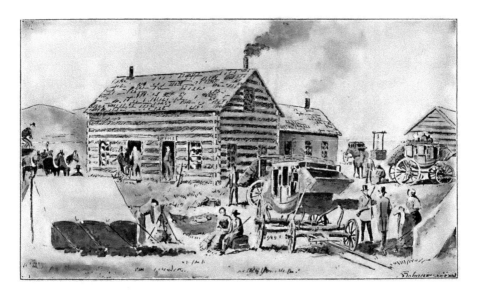

Drawing of the Latham stage station, with coaches and wagons waiting for escort. *Illustration from the book* The Overland Stage to California.

After safely escorting the one hundred wagons, the Colorado militia turned around at Camp Rankin. Heading west on the trail, the militia saw smoke choking the entire valley. Stations and ranches were lit up in flames. The only ranch prepared for the attacks was near present-day Merino. Holon Godfrey, the proprietor of a store and a blacksmith, had fortified his ranch house with a bastion and open portholes that offered a view of the entire valley. He had also constructed sod walls around the house to protect his family and employees if necessary.

When the Indians launched their attack, Godfrey was ready. From his perch in the tower, he spied a war party of Cheyenne and Sioux moving in his direction. He roused everyone from their beds—a crew of male employees, as well as his wife and children. As the adults took up arms, the war-painted Indians charged in to shoot, then quickly retreated. Over and over they charged, fired and retreated. The Godfreys took aim out the rifle ports, careful not to waste ammunition until they had a good shot. Occasionally they hit a warrior and whooped when he tumbled to the ground. Mrs. Godfrey and her eldest daughter also fired out the rifle ports while the younger children kept the extra guns loaded and ready.

The Indians then set fire to the grass and aimed flaming arrows at the roof, but Godfrey had prepared for that, too. Having dug a well inside the walls, Godfrey scurried about with a bucket in one hand and rifle

in the other, simultaneously shooting and soaking the grounds. During lulls, the women cast lead balls in molds. The younger children put hats on broomsticks and moved them in front of the windows. The attacks continued for two more days. Everyone was exhausted, not knowing if they could defend their home for a third day. Finally, soldiers arrived on the scene. They found seventeen Indian bodies scattered about the grounds and the Godfrey family all safe. Godfrey's store would become celebrated as the only structure left standing on the Overland Trail. The Indians would later refer to Godfrey as Old Wicked for his impressive stand against their siege. Godfrey relished the nickname and placed a sign above his ranch that read "Fort Wicked."

While Fort Wicked was under attack, another group of Indians had assaulted Julesburg again. Approaching just as the attack began, Captain O'Brien and a fifteen-member detail were escorting two stagecoaches from the east. O'Brien and his lieutenant, Eugene Ware, saw billows of black smoke rising from the river. They rode to the top of a ridge to evaluate the situation. Through his field glass, O'Brien could see warriors setting fire to Julesburg. All around them were hundreds more, an overwhelming number to battle on their own. Taking cover behind the hills, O'Brien and Ware

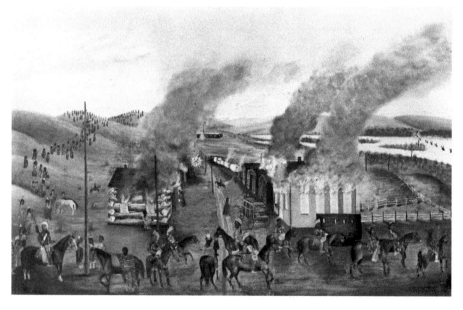

Drawing of the Cheyenne attack on Julesburg and Camp Rankin, 1865. *Courtesy Denver Public Library Western History Collection, X-9612.*

continued to keep watch until they had an opportunity to move in. As they waited, Ware spied an Indian on the opposite river bank and took a shot at him. Ware later wrote:

> *After I had made my shot, an Indian arose out of the willows on the bank on the other side of the river, and, pulling a revolver, fired six shots, and then he pulled another and fired six shots more…the Indian was better armed than I was, and as I stopped to reconnoiter, he began to fire a lot of good American words at me, and they were shot in such good English that I became satisfied that the Indian was not a Cheyenne or a Sioux…*[68]

Across the river was George Bent, firing those lead balls and profanities at Ware. When he failed to hit the lieutenant, George and his brother Charley continued north with the Dog Soldiers.

As the Indians rode out, O'Brien and Ware safely escorted the coaches through the charred city. Once arriving back at Camp Rankin, they found a diminished company of soldiers and fifty terrified citizens. Although they had laid low until the attack was over, O'Brien and Ware would forever stretch yarns about that day, writing of a heroic mad dash through the Indians, firing right and left, until they barreled through the post gates.

ENOUGH TO MAKE MEN DESERT

A year after the South Platte attacks, Captain O'Brien grew tired of the Indian campaigns. Near Fort Laramie, the restless captain mounted his horse and simply rode off. No one knew where he went or why he left. In 1866, O'Brien appeared again near his old post in Julesburg. He had not deserted as some suspected but instead had resigned his commission and ridden east to marry his sweetheart.

By then, construction of the transcontinental railroad slowly inched its way across the prairie without firm plans for exactly where the tracks would lie. One route showed the tracks running up the South Platte and then up the Poudre. Another showed the tracks touching only briefly in the northeast corner above Julesburg before jutting up to Wyoming. In either case, O'Brien knew the route would reach Julesburg. With his prior knowledge of the area, O'Brien decided he could profit in a booming railroad town. He opened a store in Julesburg, which later served as the post office as well.

Upriver, the humble Camp Rankin had transformed into a large frontier post. It was renamed Fort Sedgwick to honor the officer who oversaw Fort Lyon's construction, John Sedgwick, who was killed in the Civil War. The new fort spread beyond the original sod walls, its barracks and outbuildings lining the river valley, with a stage road cutting directly through the grounds. Fort Sedgwick included additional barracks, stables and a hospital—all constructed with a mixture of sod and lumber. The barracks had dirt-packed floors and roofs layered with twigs, canvas and mud. Inside, the barracks held eighty men. They slept two to a bunk, with lumpy straw sacks for mattresses and a single wood stove barely emitting enough heat to warm them.

During the Indian wars, General William T. Sherman was charged with inspecting the frontier outposts. When he rode into Fort Sedgwick in 1866, he wrote, "It is impossible to conceive of a more dreary waste than this whole road is."[69] His scathing reports included other forts as well:

> *Some of the posts out on the plains are really enough to make men desert. Built years ago of upright cottonwood poles, daubed with mud, and covered with mounds of earth, as full of fleas and bedbugs as a full sponge is of water. Were it not for intensely bitter winds of winter which force men to go in such holes or perish, no human being, white man, Indian, or Negro, would go inside.*[70]

As Sherman observed, the frontier posts were dismal assignments for soldiers. With a meager salary of thirteen dollars a month, the soldier purchased his own uniform and other supplies. What remained of his earnings, he often frittered away at whiskey dens or prostitution hovels called "hog ranches" that operated outside fort grounds. If caught drunk or leaving the post without permission, Fort Sedgwick's soldiers might be thrown in the guard house, publicly flogged, ordered to repeatedly dig a hole and refill it or forced to march around the parade ground with a heavy log over their shoulders. For more serious offenses like desertion, some were branded with a letter "D" on their hips.

In 1867, the journalist Henry Stanley worked as a special correspondent out west, reporting on the Indian wars for eastern newspapers. While visiting the Julesburg area, he described how one punished soldier was staked, spread eagle on the ground, face up to the blazing sun. Stanley wrote:

> *The buffalo gnats covered his face by the thousands causing intense suffering to the unfortunate fellow. "For two hours he screamed, cried, begged,*

Drawing of Fort Sedgwick in 1870, near Julesburg. *Courtesy History Colorado (Scan #10049735).*

entreated for the love of God to be let loose. For two hours he roared; I couldn't stand it any longer; I tell you, sir, his face was perfectly burned up." Such were the words of his lieutenant to a group of officers, who expressed deep commiseration for the man's sufferings.[71]

By this time, the entire town of Julesburg had moved across the river to meet the railroad construction. Along with the railroad came another temptation—the foldable city of sin called Hell on Wheels. As soon as the tracks met Julesburg, hundreds of gambling dens opened for business. What was once a frontier village of fifty people exploded into three thousand railroad workers, gun-slingers and prostitutes—earning Julesburg the moniker of "Wickedest City in the West," if only for a few short months. With the new excitement across the river, the fort's commander noted a sharp increase in desertions that year, upward of 180 soldiers, compared to 43 the previous year.

When Hell on Wheels took over the town, the honest store keepers and citizens feared for their lives. A day didn't pass when a body wasn't found floating in the river or thrown onto the streets. Citizens met at the O'Brien store, hoping to form a plan to rein in the lawless violence. Some appealed to the commander at Fort Sedgwick for assistance, but he shrugged them off. As long as the gamblers took shots at one another and not his soldiers, he didn't much care. By the end of the summer, military forces weren't needed anyway. Hell on Wheels blew on down the tracks, vacating the area entirely.

As the railroad crew moved on, Fort Sedgwick troops kept busy patrolling the old trail. Isolated incidents occurred up and down the river road—horses stolen, telegraph lines cut and lone travelers murdered—yet when the cavalry arrived on the scene, the Indians disappeared into the swells of the prairie. The journalist Stanley reported on the fruitless efforts to catch them:

> *From hill to hill, ravine to ravine, over prairie and over creeks they chase the red man, but all to no purpose. They have not succeeded in bringing one prisoner in yet…On their arrival in camp they are accosted by anxious inquiries, "What news of the Indians? Did you see any?" The answer is returned by the crestfallen captain, "Nary a one. I'm durned if I believe there are any Indians in the country!"*[72]

Upriver another post served to protect the area from Indian raids as well. After the attacks of 1865, U.S. regulars arrived to disband the Colorado militia at Camp Tyler. Behind them, three companies of Galvanized Yankees arrived to improve the post. These men were former Confederate soldiers, captured in battle and given the opportunity to serve out west rather than rot away in a Yankee prison. The new post, temporarily called Camp Wardwell, sat on a high ridge overlooking the river. The walls of sod had dried to a gleaming white because of the alkali water used in the bricks. All twenty structures sat in a square around a central parade ground, about the size of a city block. But unlike the open layout of Fort Sedgwick to the east, the camp was protected by eight-foot sod walls with loopholes and cannons positioned on two corners. Later, a visiting general decided to rename the post. He admired the commanding view of the valley and wanted to honor his aide-de-camp Christopher Morgan, who had died of asphyxiation back east by a coal gas leak in an enclosed room.

The soldiers at Fort Morgan found themselves with little to do. The railroad had taken the northern route through Wyoming, bypassing the South Platte River altogether. While some officers praised Fort Morgan with its beautiful views and abundant game for hunting, others hated the isolated location. A visiting general recommended that the fort be closed, stating that it was "so desolate that it is the next thing to imprisonment to send officers and troops here."[73]

One winter day in 1867, a group of sergeants, corporals and privates decided they had had enough of Fort Morgan. In the middle of the night, the thirty-one men silently mounted their horses and rode out into the freezing wilderness. Word of the mass desertion sparked panic in Denver,

its residents assuming they had designs to pillage the town. But less than a week later, four of them straggled into the city claiming they were forced to go along against their will. Most of the deserters successfully escaped southeast into the vast frontier, never to be spotted again. Army officials suspected they took shelter at a new set of stage stations under construction from Kansas to Denver. Others believed they had met their fate at the hands of the Cheyenne Dog Soldiers.

Around the time of the mass desertion, George and Charley Bent were also in the area with a band of Dog Soldiers. When they discovered the new stage stations leading into Denver, they were taken aback. The barren, central territory had always been free of white settlement, but now the whites had invaded that land as well. George, then growing weary of unending wars, decided to approach one of the stations and ask the employees about the plans for a central stage line. Yet when George opened his hands in peace, his brother fired shots at them. As the stage employees ran for shelter, Charley and the Dog Soldiers rode down on them, capturing one unfortunate fellow. Charley staked the struggling man to the ground and proceeded to slowly torture him. First he cut out the man's tongue, then he hacked off his genitalia and stuffed it in his mouth. In disgust, George mounted his pony and rode off. He no longer knew his brother, a boy whose blind vengeance molded him into a psychopathic killer.

George remembered the advice Black Kettle and the old chiefs had given him: the progress of the whites couldn't be halted, no matter how hard the Indians retaliated. His brother Charley would never relinquish the fight, though, and his warring band continued to terrorize the Kansas Pacific Railroad, which was slowly making its way toward central Colorado. During a confrontation with soldiers, Charley was shot and later died from his wounds.

INADEQUATE FOR PROPER PROTECTION

Down in the San Luis Valley, settlers feared for their safety. Numerous bands of Ute and Apache Indians camped in the valley, frequently raiding the ranches and stealing their stock. The army concluded that the best man to keep the peace was Kit Carson, well known and respected by both settlers and Indians. In 1866, Carson accepted the position as post commander of Fort Garland. When he arrived with four companies of the First New

Fort Garland, reconstructed on its original site. The museum is open year-round. *Photo by Sean Gallagher.*

Mexico volunteers, they found the sod buildings sagging and bowed from neglect. He wondered how the post could withhold a possible Indian attack. Carson knew he must begin repairs immediately, plus open negotiations with the local tribes.

That summer, Carson and his family settled into Fort Garland. They had spacious living quarters with a kitchen, parlor, office, dining room and private bedrooms for his wife and children. As his first order of business, Carson reported on his situation:

> *To restrain this large body I have but a Command of Some 60 Men…This is inadequate for the proper protection of Government property Alone.*[74]

Although an 1863 treaty specified that the Ute Indians should receive annuities, the tribes often did not receive the needed food from the agents. After ceding their prime hunting grounds, the Utes became dependent on the government. To ease tensions, Carson invited the local bands to visit him at Fort Garland. He allowed the Indians to freely walk into the fort and meet with him whenever they pleased. The post surgeon described Carson at these "open-house" gatherings:

It was a study to see him sitting, surrounded by them rolling cigarritos and passing the tobacco around, all the while laughing, joking, talking Spanish, or Ute tongue, with such abundant gesticulations and hand movements, that it seemed to me he talked more with his hands and shoulders than with his tongue.[75]

Here Carson met with a Ute chief whose desire for peace matched his own: Chief Ouray. Friendly and diplomatic, Ouray was the son of an Apache mother and Ute father. As a young man, he had joined a Ute band and distinguished himself as a prominent leader. Over the months, Carson and Ouray formed a mutual respect for each other. Unfortunately, not all the local tribes agreed with Ouray's negotiations with white men. They considered him a traitor.

Throughout the 1860s, warring tribes continued to raid vulnerable ranches and farms in southern Colorado. The only military posts were Fort Lyon, near the Kansas border, and Fort Garland, in the San Luis Valley, leaving a wide swath of unprotected territory in between. Carson's troops could protect the San Luis Valley to some extent but could do little for the ranches on the east side of the Sangre de Cristo Mountains. When the army discussed plans for another fort on the eastern slope of the mountains, Carson recommended a site along the Huerfano River near the base of the Spanish Peaks. In mid-August 1866, plans for a new post were underway. A month into construction for the new Fort Stevens, General Sherman inspected the foundation and halted

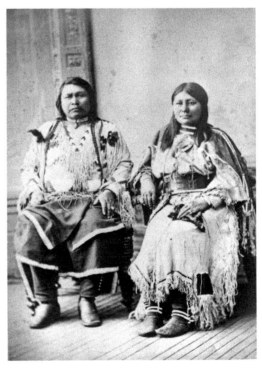

Portrait of Chief Ouray and wife Chipeta between 1870 and 1880. *Courtesy Denver Public Library Western History Collection, Z-2726.*

work. Sherman concluded that there was no justification for a fort at that location. Abruptly the post was abandoned before it was garrisoned, giving Fort Stevens the dubious honor of the fort with the shortest lifespan in Colorado history.

A new site was selected about twenty miles east of Pueblo (present-day Avondale). In the spring of 1867, Federal troops arrived in Pueblo while construction began for Fort Reynolds (named for John Reynolds, a West Pointer killed in Gettysburg). The military reservation extended twenty-three square miles, making the post the largest in Colorado. Situated around a parade ground, about four hundred feet square, the frame and adobe buildings included barracks, mess halls, a hospital and laundry. Unlike many frontier posts, Fort Reynolds was not isolated from social activity. The nearby business plaza built by frontiersman Charles Autobees (who had also supervised Fort Garland construction) provided the soldiers with diversions at dance halls and saloons.

The same year that Fort Reynolds was established, old Fort Lyon was abandoned after continual flooding along the Arkansas River and moved to a new site just sixty miles east of Fort Reynolds. The new Fort Lyon sat on the Santa Fe Trail, near William Bent's ranch. Since Fort Lyon lay closer to the Plains Indian wars, the military invested more resources and manpower into building it. Under the command of Captain William Penrose, soldiers moved to the new site and camped in tents while they erected the sandstone barracks and sundry adobe buildings. Occasionally construction was interrupted by Indian attacks in the area, and soldiers halted their work to chase the culprits. Over the next few years, Fort Lyon would grow to include a garrison of four thousand men.

As Fort Lyon became the main staging area for the Indian campaigns, Fort Reynolds became nothing more than a supply post. That dull assignment suited some of its one hundred soldiers just fine. One said, "If our lot had been cast as an enlisted soldier in the regular army, we would wish no better fortune than to be sent to Fort Reynolds."[76]

Fort Reynolds's only major call to arms came in January 1868, to quell a local war between white Americans and Hispanics down in Trinidad. A drunken quarrel began on Christmas Day, escalating into a murder, a jailbreak and a Wild West gunfight in the streets. Even a local Ute tribe rode into town and took up sides. By the time troops from Fort Reynolds and Fort Lyon arrived, they discovered that the fight had already ended. Still, they decided to occupy the town in what they called the "Post at Trinidad" to deter further trouble.

Back at Fort Lyon, an ailing Kit Carson was brought to the newly constructed hospital. He had recently resigned as Fort Garland's commander and moved his family to nearby Boggsville. After returning from a trip to Washington, D.C., where he negotiated another Ute treaty with Chief Ouray, his beloved wife, Josefa, died from complications of childbirth. The grief-stricken Carson succumbed along with her. In the Fort Lyon hospital, Carson died at age fifty-nine.

Like Carson, William Bent also suffered from poor health. At age sixty, he caught pneumonia. With daughter Mary and son Robert at his side, Bent lay in bed at his ranch remembering his days on the frontier. He may have regretted his broken relationship with son Charley, perhaps wishing they had resolved their differences before Charley was killed. As for son George, Bent was proud of the young man. George had left his warring ways behind and joined Major Wynkoop as his translator in treaty talks.

After William Bent died, the Cheyenne Dog Soldiers made their last stand on the open prairie of Colorado. At Summit Springs (south of present-day Merino), a village of Dog Soldiers was surprised by the Fifth Cavalry under the leadership of General Eugene Carr and his chief scout, the future Buffalo Bill Cody. In July 1869, Carr's forces killed and captured many of the Dog Soldiers, also managing to save a white woman held captive there. The rest of the band scattered, never finding a safe home on the Colorado plains again.

At the dawn of the 1870s, the forts on the eastern plains lost their purpose. Fort Collins was the first to close in 1867, followed a year later by Fort Morgan. Both sites became transportation hubs along branch lines of the railroad, later growing into thriving Colorado cities. Next, the army dismantled Fort Sedgwick in 1871 and Fort Reynolds in 1872. Only Fort Lyon and Fort Garland remained to defend an increasingly docile frontier.

THE UTES MUST GO
(1870–1880)

As the Cheyenne and Arapaho were chased off the plains, the land west of the Continental Divide was still occupied by the Ute Indians. Because of the 1868 treaty Kit Carson and Chief Ouray helped negotiate, the Utes could roam all the mountains and valleys west of present-day Gunnison (one-third of the Colorado Territory). In the deal, Ouray received a sizable farm in the Uncompahgre Valley, not far from where Robidoux's fort once stood. The treaty also established two Ute agencies, one along the White River for the northern Ute bands (near Meeker) and another called Los Piños for the Southern and Uncompahgre Ute bands (near Saguache).

After the treaty was signed, Ouray and his fellow tribesmen assumed their hunting grounds were protected from American interlopers, but all through the mountains, new discoveries of gold and silver lured prospectors onto Indian grounds. Although the Utes ceded much of their land in another treaty in 1873, it wasn't enough to satisfy the miners. Coloradans complained bitterly to government officials, arguing that a region so rich in minerals shouldn't be wasted. Ignoring reservation boundaries, prospectors rushed into the central Rockies and San Juan Mountains. Some built stockades on Indian land in direct defiance of government regulations, including one near Glenwood Springs in 1879 (appropriately named Fort Defiance). In the San Juans, Fort Garland troops attempted to push out whites occupying reservation land, but when faced with the miners' ready firearms, the soldiers decided it wasn't a battle worth fighting.

In the mid-1870s, as the country emerged from a deep recession, Coloradans insisted that the only barrier to their prosperity was the

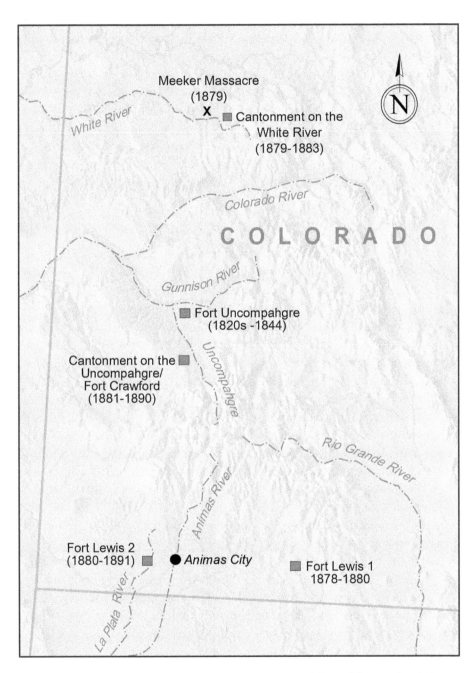

Colorado forts on the Western Slope, showing the site of the Meeker Massacre in 1879. *Map by Sean Gallagher.*

Ute Indians. After Colorado achieved statehood in 1876, the leading candidate for state governor, Frederick Pitkin, campaigned on the slogan, "The Utes Must Go!" When Pitkin won the election, the Utes worried about their tenuous situation. Adding to their problems were the strict Indian agents, who insisted they learn to farm if they wanted to receive government annuities. Some tribes complied while others clung to their nomadic ways.

By the end of the decade, disagreements between Ute chiefs and the White River Indian agent Nathan Meeker would escalate into murder. The incident would lead to a final building boom of Colorado's frontier forts.

Wholly Unlike Cooper's Red Men

In the early 1870s, days at Fort Lyon passed without much incident. The soldiers spent their time chasing horse thieves and cattle rustlers, who were far more numerous than marauding Indians. On occasion, they might encounter Ute warriors, who traveled down from the mountains to battle enemy tribes.

Near Fort Lyon, in the village of Las Animas, a dozen Ute braves stormed into a store where some army wives were shopping. With faces painted for war, the Indians shoved past the ladies and threw an officer's wife, Frances Roe, over the counter. Another warrior rode his pony through the door, trapping the ladies inside. Roe watched, frozen in fear as the Utes grabbed whatever ammunition they could find—gunpowder, lead balls and knives. Once they cleared the store, the Utes rode down the street in a swirl of dust and war cries. Roe emerged from behind the counter, entirely indignant. She later wrote about the encounter, saying how the Indians were disappointing savages "so wholly unlike Cooper's red men."[77]

Like many Eastern-bred ladies, Roe had gleaned all her Indian knowledge from James Fenimore Cooper novels. These army wives were not prepared for the harsh reality of the 1870s frontier. Roe had traveled to Colorado to join her husband at Fort Lyon, a large post by that time but still surrounded by untamed land. Upon seeing the fort for the first time, she wrote in a letter:

> *It reminds one of a prim little village built around a square, in the center of which is a high flagstaff and a big cannon. The buildings are very low and broad and are made of adobe—a kind of clay and mud mixed together—and*

Soldiers standing outside Fort Garland's main gates in 1874. *Courtesy Library of Congress, Prints & Photographs Division.*

the walls are very thick. At every window are heavy wooden shutters, that can be closed during severe sand and windstorms.[78]

Over the mountains from Fort Lyon, the garrison at Fort Garland passed its time peacefully as well. The railroad did not reach the post until 1877, leaving it isolated from civilization. The army often assigned foreign-born recruits to the fort, men hailing from Germany, Switzerland, France and Denmark, many unable to speak English. For a few years, the Ninth Cavalry was also stationed at Fort Garland, a regiment composed entirely of black men called the "Buffalo Soldiers." Although no one is certain how and when

the black soldiers got the moniker, Roe said in her letters, "The Indians call them 'buffalo soldiers,' because their woolly heads are so much like the matted cushion that is between the horns of the buffalo."[79]

In 1875, the army recommended Fort Garland's closure. But before they could dismantle the post, tensions between white prospectors and Ute Indians escalated once more. The army kept Fort Garland open and also established another post in Pagosa Springs in 1878. Originally called Cantonment at Pagosa Springs, the post was later renamed Fort Lewis, after Lieutenant Colonel William Lewis, who was killed in the Plains Indian Wars. At the new post, the infantry and cavalry performed all the manual labor. They constructed ten log cabins, occupied by ten men each, and log stables for their animals. No railroad reached the small post, requiring their mail and supplies to be transported over the long, winding wagon road from Animas City (Durango).

Now with two posts in the southern mountains, the white miners may have felt a little safer, but not much. Newspapers editorialized that the Utes should assimilate into white culture. Many of the Utes, however, vowed never to relinquish their former ways.

ALL THE GOOD PEOPLE WILL REMEMBER THEM

The leader of a successful farming colony (future Greeley) felt sure he could teach the Utes how to farm. After accepting an appointment as Indian agent, Nathan Meeker traveled to the White River reservation in northwest Colorado. There he would insist that the Ute Indians learn to till the soil. The Ute men did not care for the pompous Meeker and resisted his attempts to make them farm. Frustrated, Meeker threatened to send for troops from Fort Steele, Wyoming. The Utes ignored him, laughing that he had no authority to call for troops. Some even defied the reservation boundaries altogether, causing trouble by stealing stock from settlers in the neighboring valley. In response, Governor Pitkin sent the Buffalo Soldiers from Fort Garland to Troublesome Creek (present-day Kremmling), where some farms had been raided. But the troops were far to the east of Meeker's agency, unable to assist him with the intractable Indians.

Taking a new tactic, Meeker decided to plow under a pasture the Ute Indians used for racing their ponies, telling the men it would now be farmland. One of the chiefs, a man called "Johnson," confronted Meeker.

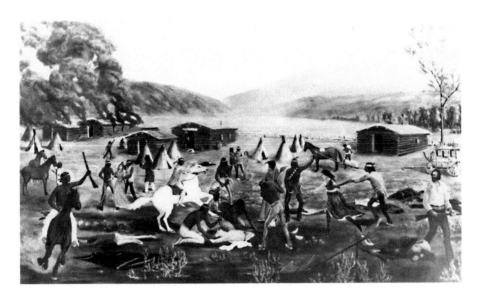

Painting that depicts the Meeker Massacre on the White River in northwest Colorado.
Courtesy History Colorado (Scan #10049736).

Their heated words escalated into a shoving match, an altercation that prompted Meeker to wire Washington, D.C. The Utes assaulted him, he said; he needed soldiers to protect him. Finally, Meeker got the response he desired. The government ordered troops to leave from Fort Steele and ride south to his agency.

When the Utes heard that 175 soldiers were riding their way, they formed plans to confront them. The massacre at Sand Creek and Custer's defeat at Little Big Horn were still fresh and painful memories to everyone—large numbers of troops amounted to disaster. The Utes sent emissaries to speak with the commander, Major Thomas Thornburgh. They informed him that bringing in troops violated the terms of the agency. Thornburgh wasn't swayed and, suspecting treachery, pushed forward with his column of soldiers.

Fifteen miles from the agency, the Utes ambushed a forward detachment. At Milk Creek, they killed thirteen men, including Thornburgh. The main body of soldiers then found themselves trapped by a larger band of Ute warriors, upward of three hundred men in the surrounding hills. They held off the attack, with one soldier escaping through the battleground to alert authorities. Three days later, thirty-five Buffalo Soldiers broke through enemy lines, but even with the increased numbers of men, the cavalry could not defeat the Utes. Fighting continued for several days

until yet more reinforcements arrived from the north and enabled them to drive off the Indians.

When the embattled soldiers finally reached the White River agency, they found the buildings charred and dead bodies strewn on the ground. Meeker and ten of his employees had been murdered. The women and children, including Meeker's wife and daughter, were nowhere to be found. The soldiers occupied the agency, sending out patrols, but couldn't locate the perpetrators.

Unknown to the soldiers, the three captured women and two children were led southwest (near present-day Grand Junction), where they huddled inside a lodge along Plateau Creek. The wife of Chief Johnson felt sorry for the captives, trying to assuage their fears. She fussed over the frightened children, making them moccasins and providing them with blankets. She told the whites how she too had been a captive many years ago, held by the Arapaho near Fort Collins. If not for the kindness of the soldiers who rescued her and nicknamed her "Susan," she may have suffered life-long enslavement in an enemy tribe.

Angry over the murder of Meeker and his employees, Susan confronted the Ute men of her tribe. Reminding them that soldiers would punish them severely, she finally convinced the Utes to turn over their prisoners. The white women were exceedingly grateful to Susan. After twenty-three days of captivity, Mrs. Meeker said:

> So long as I remember the tears which this good woman shed over the children, the words of sympathy which she gave, the kindness that she continually showed to us, I shall never cease to respect her and to bless the goodness of her brother, Ouray, the Spanish-speaking chief of the south. I trust all the good people will remember them.[80]

As Susan suspected, the Meeker massacre only fanned the flames of resentment in Colorado. Although the government led investigations into the attack, only one Ute man served a sentence in Leavenworth for the murders. Amidst fears of another uprising, the army decided more military installations were necessary to intimidate the Indians. Near the site of the massacre, the army camped upriver from the burned-out agency. They called their camp the Cantonment on the White River. As the soldiers moved in, the Ute bands scattered throughout the northern territory, leaving little to occupy the soldiers' time except building log cabins and patrolling the area.

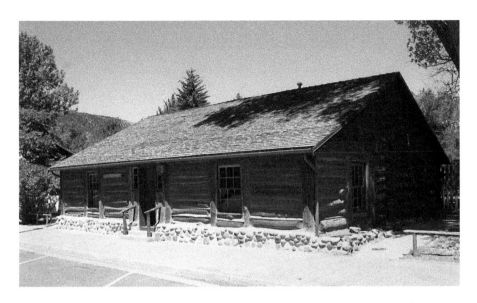

Photo of the officers' quarters at the Cantonment on the White River, now part of the White River Museum in Meeker. *Photo by Sean Gallagher.*

In the southwest corner of Colorado, the army settled around a newly established Southern Ute reservation. It formed cantonments on the La Plata River (Hesperus), on the Mancos River (Mancos) and in Animas City (Durango), but these camps were only temporary. The army wanted to consolidate the troops in a location that offered the best protection for miners and settlers in southwest Colorado.

Fort Lewis at Pagosa Springs was the nearest post, but it was a hard ride over the mountains, requiring days of travel. Eventually, the army decided on the bluffs above the La Plata River, which could protect not just miners in the San Juans but also settlers along the four corners of Colorado, New Mexico, Arizona and Utah. The year after the Meeker massacre, the army dismantled Fort Lewis in Pagosa Springs and began rebuilding it on the La Plata site. The second Fort Lewis would be more impressive. The post included not just the standard barracks, officers' quarters and corrals but also a theater and dance hall. All the buildings were constructed of lumber, cut from a sawmill erected at the site and arranged around one of the largest parade grounds in the country, a full 500 by 150 yards.

As the army constructed these new camps and forts, the government worried that Chief Ouray would unite the Utes in a massive war against the whites. While stationed at the Cantonment on the Rio Mancos, a sergeant recalled:

Photo of Fort Lewis in 1881, near Hesperus. *Courtesy History Colorado (Scan #10049733).*

Old Ouray kept us very busy and guessing during October and November, with skirmishes in the nearby mountains and canyons, but no really serious or pitched battles; our losses were small, very few killed and wounded.[81]

Ouray had no involvement in the raids, nor any intention of launching a war. He and his wife, Chipeta, lived comfortably in a little cabin in the Uncompaghre Valley, surrounded by rich farmland and even richer mountains. His band had not participated in the murders at the White River reservation, and he saw no reason to worry. In fact, he had tried to persuade his kinsmen to stop all attacks against the whites, but like the sergeant at Rio Mancos, the whites did not distinguish between Ouray's band and any other.

Ouray was upset about the Meeker massacre, feeling the actions of a small group ruined all his diplomatic work. Once again Ouray and Chipeta traveled to Washington, D.C., to negotiate with the government. Without his trusted friend Kit Carson to help him, Ouray was disappointed with the outcome. The Utes must cede more land, the government told them. Ouray returned to Colorado and tried to convince the Southern Ute to accept the new terms, but none trusted the Americans, or Ouray for that matter. In his own defense, Ouray told them that forming treaties with whites was "such an agreement as the buffalo makes with the hunter when

his hide is pierced by arrows…All he can do is lie down and cease every attempt at resistance."[82]

Ouray wouldn't live to see the final blow to his people. In May 1880, while he lay dying of a liver ailment in a Southern Ute camp, fifteen companies of Fort Garland cavalry and infantry trudged single file over Cochetopa Pass and into the Uncompahgre Valley. Their orders were to keep peace between the Indians and miners, but the government had another purpose in mind. As soon as they could locate new lands for the Ute, the soldiers were to escort them out of Colorado entirely.

WATCHING THEM PASS IN SINGLE FILE

In the Uncompahgre Valley, upward of 250 soldiers drilled, marched and patrolled, presenting an intimidating presence in front of the Uncompahgre Ute tribe. The soldiers pitched their tents along the river, first calling their camp the Cantonment on the Uncompahgre, but after a chilly winter, they decided a more permanent post was needed. Just south of present-day Montrose, they hauled timber to a sawmill and erected comfortable barracks. Although their quarters were warm, they had little furniture, requiring them to improvise with whatever materials they could find. For beds, they filled packing boxes with straw. For tables, they laid pine boards across sawhorses. For chairs, they used fresh tree stumps that made for a sticky, sappy seat. After quarters were established, some of the officers brought their families to the new fort. When the officers' wives arrived after a jolting journey over the mountains, they found every dish of their carefully packed china broken to shards.

That summer of 1881, Colonel Ranald Mackenzie met with the Uncompahgre chiefs to tell them they had no choice but to leave for a new reservation in Utah. At first, the leaders refused. Some tried to propose alternatives to their removal. Mackenzie stood firm. He had his orders. If they wouldn't go peacefully, he would use force. Out-manned and out-gunned, the Ute Indians quietly submitted.

The daughter of a company captain remembered the sad day when the Ute families folded up their lodges, tethered their animals and marched in a long line out of the valley. As the troops followed close behind the Utes, she remembered:

> *I was standing at the door of our house, watching them pass in single file, Indian style, all day long, the horses drawing the travois.*[83]

Photo of Company K, Tenth Infantry, at Fort Crawford in 1886. *Courtesy History Colorado (Scan #10049732).*

As soon as the Utes vacated the valley, white settlers claimed the land for their own. Around the state, the frontier posts reduced their garrisons to fewer and fewer soldiers. With some reports of isolated Indian attacks continuing to filter into the newspapers, nervous miners and settlers appealed to the government to keep the posts open. The Cantonment on the Uncompahgre received permanent status in 1886 as Fort Crawford, named to honor Captain Emmet Crawford, who was killed in the Indian wars. Just four years later, the fort closed. All the troops were moved out, leaving behind only a single caretaker who homesteaded the property. He and his wife would be forever surrounded by the ghostly reminders of bugles, blue coats and the Ute people who once roamed the land.

EPILOGUE

By the 1880s, railroads stretched across the state and towns sprouted over the land. With trains chugging through Colorado, soldiers and settlers now had quick transportation. The once isolated posts were no longer needed, and one by one, they began to close.

In 1883, troops filed out of the Cantonment on the White River, leaving its log quarters behind in the growing town of Meeker. That same year, Fort Garland soldiers lowered the flag and marched to Fort Lewis. The old Fort Garland site changed hands numerous times until the Colorado Historical Society opened it as a museum in the 1950s. Soldiers were garrisoned at Fort Lewis until 1891, when it became an Indian boarding school. In 1911, the Fort Lewis site was converted to a campus of higher learning; and in 1956, the school transferred operations to its present location in Durango (Fort Lewis College). On the eastern plains, Fort Lyon remained until 1897. The U.S. Navy reopened the site in 1906 as a sanatorium for sailors and marines suffering from tuberculosis. Fort Lyon eventually became a Veterans Administration hospital in operation until 2001 and was then used as a correctional facility until 2012.

To consolidate frontier posts across the plains, the U.S. Army established Fort Logan on 640 acres south of Denver. The original tent camp was first named for General Philip Sheridan, who selected the site in 1887. But Sheridan wanted the post named for the Illinois senator John Logan, who introduced the congressional bill to create it. Over the years, Fort Logan included permanent barracks and other buildings, surrounding a thirty-two-acre parade ground. In 1909, Fort Logan was used as a recruiting center,

U.S. Signal Corps weather station atop Pikes Peak, from a photo by William Henry Jackson. *Courtesy Denver Public Library Western History Collection, WHJ-472.*

with future president Dwight D. Eisenhower serving there. At the start of World War II, another fort was established between Colorado Springs and Pueblo. The new Fort Carson was named to honor Kit Carson, the wiry mountain man who once served as a hunter and guide for many Colorado forts, as well as the commander of Fort Garland. By the close of World War II, two posts were no longer necessary along the Front Range. Fort Logan closed in 1946. Fort Carson remains today, an installation that now stretches over 137,000 acres with a population of nearly fourteen thousand.

All these forts can trace their history back to a wayward explorer named Zebulon Pike, who once spied a blue mountain that he believed no one could scale. Not only did future pilgrims ascend its peak, but also, in 1873, the U.S. Signal Corps built a weather station at the summit. From here, tourists could stand on the very pinnacle that had eluded Zebulon Pike years before, a magnificent view that inspired the patriotic hymn "America the Beautiful."

DAY TRIPS

Bent's Old Fort (US-50 to La Junta)

About an hour and thirty minutes east of Pueblo is the beautifully reconstructed Bent's Old Fort, which is operated by the National Park Service. The park offers self-guided tours, demonstrations and living history interpreters. From US-50 in La Junta, take CO-109 north, then CO-194 east and follow the signs to Bent's Old Fort.

Other sites on US-50:

- **Fort Lyon/Kit Carson Chapel**: You can see a historical marker for old Fort Lyon and Kit Carson's chapel (constructed from the stones of the doctor's quarters where Carson died). About six miles east of Las Animas, turn south onto CO Rd-15, then east on CO Rd-Hh.

- **Bent's New Fort/Fort Wise marker**: This site is on private property, but you can drive near its location on dirt roads. Eleven miles east of Hasty, turn south onto CO Rd-35 for one mile, turn east at CO Rd-JJ and take the turn south on CO Rd-35.25. The site of Bent's New Fort and Fort Wise are located to the west.

EL PUEBLO HISTORY MUSEUM (PUEBLO AREA)

The El Pueblo History Museum includes a re-created 1840s trading post and plaza with self-guided tours and exhibits throughout the year. The museum is operated by History Colorado and is open year-round. The actual site of El Pueblo has been partially excavated near the museum at the corner of North Union and Victoria Avenues.

Other sites around or near Pueblo:

- **Fort Independence/Mormon Battalion marker**. At the Runyon Sports Complex on Locust Street and Stanton Avenue, a marker is located behind the baseball field.

- **Fort Reynolds marker**: About one mile east of Avondale on US-50, a stone marker is located on the north side of the road (mile marker 333, Fifty-second Lane).

- **Fort Francisco**. In La Veta, about one hour southwest of Pueblo, you can visit the refurbished trading post and plaza built by the Fort Garland sutler John Francisco. From Pueblo, take I-25 south and US-160 west, then take CO-12 into La Veta. The museum is at 306 South Main Street.

FORT GARLAND AND PIKE'S STOCKADE (ALAMOSA AREA)

The Fort Garland museum is located on the original fort foundation in the town of Fort Garland. The grounds include reconstructed adobe buildings with self-guided tours and exhibits. The museum is operated by History Colorado and is open year-round. From US-160, turn south on CO-159. As you turn, you will see the museum on the west side of the road.

In the summer, you can also visit Pike's Stockade, which was reconstructed at its original location on the Conejos River. From Alamosa, go south on State Street, proceed to Twelfth Street and follow it out of town (Twelfth Street becomes South River Road). Go seventeen miles until you reach the gates of Pike's Stockade (bring mosquito repellent).

Other sites nearby:

- **Frémont's Christmas Camp (Camp Hope)**. You can still see evidence of chopped stumps where Frémont's fourth expedition camped in the San Juan Mountains. The site is twenty-four miles northwest of Del Norte, about four miles from Cathedral Campground.

- **Fort Massachusetts site**. Although this site is on private property, students in the archaeological field-training program of Adams State University perform excavations there.

Fort Uncompahgre (Delta Area)

The City of Delta constructed an impressive replica of Fort Uncompahgre several miles from its original location. Located in Confluence Park, the fort offers self-guided tours with many historical items in the trappers' cabins and around the grounds. From Grand Junction, take US-50 southeast to Delta. Just south of the river, turn west on Gunnison River Drive. The fort is on the north side of the road. From the parking lot, take the walking path toward the trees. (Visiting hours are limited; call the City of Delta before you go.)

If you are continuing south toward Ouray, you can also see a historical marker for Fort Crawford on the west side of US-550, approximately seven miles south of Montrose.

White River Museum (Meeker Area)

In Meeker, you can see some remaining log quarters of the Cantonment on the White River. The officers' quarters are now part of the White River Museum, open to the public. From I-70 at Rifle, turn north on CO-13 to Meeker. The museum is located at 565 Park Street. The Rio Blanco courthouse sits on the former parade grounds. You can also see a marker for the massacre site, which is located three miles west of town on CO-64, on the south side.

Fort Lupton and Fort Vasquez (Front Range Towns)

Historic Fort Lupton and the Fort Vasquez Museum are both easy drives from Front Range towns. From US-85 at the town of Fort Lupton, take CO Rd-14½ and follow the signs to Historic Fort Lupton. The South Platte Valley Historical society reconstructed the fort to its former glory just yards from its original location. The Fort Lupton Historic Park and Rendezvous site offers self-guided tours and exhibits. The site is also host to a variety of seasonal events, including the rendezvous of the Tallow River Trappers (a living history branch of the society).

About eight miles north of Fort Lupton, the Fort Vasquez museum is located near the original fort site, just south of Platteville. The museum includes interesting artifacts of fur-trading days and a partial reconstruction of the fort outside. The museum sits in between the north and southbound lanes of US-85.

Other sites along the Front Range:

- **Fort St. Vrain marker**. From Platteville, go north on US-85, turn north on CO Rd-27 (CO-60) and then west on CR-40 toward the river. The marker is located on the north side. The actual site is on private property.

- **Fort Collins**. The fort was located in old town Fort Collins, between Jefferson Street and the Poudre River. All the buildings were dismantled, except for a stone cabin that now resides in the Heritage Courtyard of the Fort Collins Museum & Discovery Science Center.

- **Fort Namaqua marker**. On the west side of Loveland, you can see a marker for the trading post and home of frontiersman Mariano Medina in Namaqua Park. From US-34, turn south on Namaqua Road. The park is on the east side.

Historic Fort Logan (Denver Area)

South of Denver, you can still see some remaining buildings of Fort Logan. The field officers' quarters are now a museum maintained by the Friends

of Historic Fort Logan. The museum is open to the public on the third Saturday of every month at 3742 West Princeton Circle.

Near downtown Denver, you can also see a historic marker for Camp Weld on the corner of Eighth Avenue and Vallejo Street.

FORT SEDGWICK MUSEUM (I-76 TO JULESBURG)

The Fort Sedgwick Museum contains interesting artifacts of the old fort, but you may need to make an appointment to visit. The museum is located at 114 East First Street in Julesburg. You can also take a drive on CO Rd-28 to see historical markers and an interpretive history of the area, including the location of Fort Sedgwick.

Other sites along I-76:

- **Valley Station marker**. Exit at Sterling, heading west. Turn north on CO Rd-370 (immediately off I-76). The historical marker is located on the north side of CO Rd-370.

- **Fort Wicked marker**. Southwest of Merino, you can see the marker for Fort Wicked on US-6 and CO Rd-2.5.

- **Fort Morgan marker and museum**. In Fort Morgan you can visit the museum at 414 Main Street, which includes a display of the fort's history. A marker for the old fort site is located in a city park on Grant Street.

NOTES

Contested Borders

1. Pike, *Expeditions of Zebulon Montgomery Pike*, 458.
2. Ibid., 480.
3. Ibid., 498.
4. Ibid., 505.
5. Ibid., 509.
6. Ibid., 510.
7. Thomas, *From Fort Massachusetts to the Rio Grande*, 84.

Trading Post Wars

8. Carson, *Kit Carson's Own Story of His Life*, 18.
9. Lecompte, "Gantt's Fort," 116.
10. Ibid., 121.
11. Field, "Sketches of Big Timber," 104.
12. Smiley, *Semi-Centennial History*, 146.
13. Hyde, *Life of George Bent*, 84.
14. Colorado Historical Society and Litvak, *Fort Vasquez Museum*, 29.
15. Lupton, *The Fur Trading Posts*, 9.
16. Hafen, "Fort Jackson," 13.
17. Field, "Sketches of Big Timber," 106.
18. Smith and Hafen, "With Fur Traders," 171.

19. Ibid., 172.

20. Hafen, *Fort Davy Crockett*, 2.

21. Smith and Hafen, "With Fur Traders," 182.

22. Sage, *Rocky Mountain Life*, 98.

23. Ibid., 209.

24. Lavender, *Bent's Fort*, 229.

25. Parkman, *The California and Oregon Trail*, 330–31.

Manifest Destiny

26. Carson, *Kit Carson's Own Story of His Life*, 45.

27. Frémont, *Report of the Exploring Expedition*, 31.

28. Ibid., 110.

29. Ibid., 288.

30. Ibid., 119.

31. Hill, "Antoine Robidoux," 129.

32. Ibid., *In View of the Mountains*, 129–30.

33. Magoffin, *Down the Santa Fe Trail*, 61.

34. Ibid., 61.

35. Ibid., 68.

36. Ibid., 67.

37. Hyde, *Life of George Bent*, 85.

38. Garrard, *Wah-To-Yah*, 80.

39. Ibid, 66.

40. Ibid., 134–35.

41. Ibid., 198.

42. Hyde, *Life of George Bent*, 88.

43. Carson, *Kit Carson's Own Story of His Life*, 87–88.

Gold and the Civil War

44. Hyde, *Life of George Bent*, 96.

45. Parkman, *The California and Oregon Trail*, 345.

46. Hyde, *Life of George Bent*, 94.

47. Stegmaier and Miller, *James F. Milligan*, 136.

48. Ibid., 151.

49. Ibid., 181.

50. Conard, *"Uncle Dick" Wootten*, 370.

51. Lavender, *Bent's Fort*, 367–68.

52. Perkin, *The First Hundred Years*, 238.

53. Colorado Historical Society and Carson, *Fort Garland Museum*, 43.

54. Gilpin, "Governor's Message."

55. *Rocky Mountain News*, October 24, 1861.

56. Malkoski, *This Soldier Life*, 7.

57. Ibid., 58.

58. Hollister, *Colorado Volunteers*, 60.

59. Ibid., 60.

60. Sanford, "Life at Camp Weld," 136.

61. Gray, *Cavalry and Coaches*, 35.

WAR ON THE PLAINS

62. Lambert, "Plain Tales of the Plains," ch. 5, 19.

63. Hyde, *Life of George Bent*, 146.

64. Lambert, "Plain Tales of the Plains," ch. 4, 11.

65. Ibid., 12.

66. Williams, *Fort Sedgwick Colorado Territory*, 14.

67. Root, *The Overland Stage to California*, 331.

68. Ware, *The Indian War*, 498.

69. Williams, *Fort Sedgwick Colorado Territory*, 52.

70. Hampton, "Problems of the Frontier Soldier," 129.

71. Stanley, *My Early Travels*, 121.

72. Ibid., 110.

73. Patten, 237.

74. Colorado Historical Society and Carson, *Fort Garland Museum*, 46.

75. Ibid, 46.

76. Taylor, "Fort Stevens," 155.

THE UTES MUST GO

77. Roe, *Army Letters*, 14.

78. Ibid., 6.

79. Ibid., 65.

80. Dawson and Skiff, *The Ute War*, 144.

81. Delaney, *Blue Coats*, 12.
82. Decker, *"The Utes Must Go!,"* 41.
83. Nankivell, "Fort Crawford," 60.

BIBLIOGRAPHY

BOOKS

Abert, James William. *Expedition to the Southwest: An 1845 Reconnaissance of Colorado, New Mexico, Texas and Oklahoma.* Lincoln: University of Nebraska Press, 1999.

Abert, J.W., Philip St. George Cooke, William H. Emory and Abraham Robinson Johnston. *Notes of a Military Reconnaissance, from Fort Leavenworth, in Missouri, to San Diego, in California, Including Part of the Kansas, Del Norte, and Gila Rivers.* Washington, D.C.: Wendell and Van Benthuysen Printers, 1848.

Bancroft, Hubert Howe. *History of the Life of William Gilpin: A Character Study.* San Francisco, CA: The History Company Publishers, 1889.

Beckner, Raymond M. *Old Forts of Southern Colorado.* Pueblo, CO: O'Brien Printing & Stationery, 1975.

Blevins, Tim, Matt Mayberry, Chris Nicholl, Calvin P. Otto and Nancy Thaler. *"To Spare No Pains": Zebulon Montgomery Pike and His 1806–1807 Southwest Expedition.* Colorado Springs, CO: Pikes Peak Library District, 2007.

Boyd, Leroy. *Fort Lyon, Colorado: One Hundred Years of Service.* Colorado Springs, CO: H&H Printing, 1982.

Brandes, T. Donald. *Military Posts of Colorado.* Fort Collins, CO: The Old Army Press, 1973.

Brotemarkle, Diane. *Old Fort St. Vrain.* Boulder, CO: Johnson Printing, 2001.

Brown, Seletha. *Rivalry at the River.* Boulder, CO: Johnson Publishing Company, 1972.

Carson, Kit. *Kit Carson's Own Story of His Life: As Dictated to Col. and Mrs. D.C. Peters.* Edited by Blanche C. Grant. Santa Barbara, CA: The Narrative Press, 2001.

Colorado Historical Society and Dianna Litvak. *El Pueblo History Museum: A Capsule History and Guide.* Denver: Colorado Historical Society, 2006.

———. *Fort Vasquez Museum: A Capsule History and Guide.* Greeley: Colorado Historical Society, 2009.

BIBLIOGRAPHY

Colorado Historical Society and Phil Carson. *Fort Garland Museum: A Capsule History and Guide.* Denver: Colorado Historical Society, 2005.

Conard, Howard Louis. *"Uncle Dick" Wootton: The Pioneer Frontiersman of the Rocky Mountain Region.* Columbus, OH: Long's College Book Co., 1950.

Dawson, Thomas F., and F.J.V. Skiff. *The Ute War: A History of the White River Massacre.* Denver, CO: Tribune Publishing House, 1879.

Decker, Peter R. *"The Utes Must Go!": American Expansion and the Removal of a People.* Golden, CO: Fulcrum Publishing, 2004.

Delaney, Robert W. *Blue Coats, Red Skins & Black Gowns: 100 Years of Fort Lewis.* Durango, CO: Durango Herald, 1977.

DeWitt, Donald. *Pike and Pike's Peak: A Brief Life of Zebulon Montgomery Pike and Extracts from His Journal of Exploration.* Colorado Springs: Colorado College, 1906.

Field, Ron. *Forts of the American Frontier, 1820–91: Central and Northern Plains.* Oxford, UK: Osprey Publishing, 2005.

Frémont, John C. *Report of the Exploring Expedition to the Rocky Mountains in the Year 1842 and to Oregon and North California in the Years 1843–44.* Washington, D.C.: Gales and Seaton Printers, 1845.

Garrard, Lewis H. *Wah-To-Yah, and The Taos Trail; or, Prairie Travel and Scalp Dances with a Look at Los Rancheros from Muleback and the Rocky Mountain Campfire.* Cincinnati, OH: H.W. Derby & Co., 1850.

Gray, John S. *Cavalry and Coaches: The Story of Camp and Fort Collins.* Fort Collins, CO: Old Army Press, 1978.

Hafen, LeRoy R., ed. *The Mountain Men and the Fur Trade of the Far West.* Vol. 2. Glendale, CA: The Arthur H. Clark Company, 1965.

Halaas, David Fridtjof, and Andrew E. Masich. *Halfbreed: The Remarkable True Story of George Bent; Caught between the Worlds of the Indian and the White Man.* Cambridge, MA: Da Capo Press, 2004.

Hollister, Ovando J. *Colorado Volunteers in New Mexico, 1862.* Chicago: The Lakeside Press, 1962.

Humphreys, M.G. *The Boy's Story of Zebulon M. Pike: Explorer of the Great Southwest.* New York: Charles Scribner's Sons, 1911.

Hurd, C.W. *Bent's Stockade: Hidden in the Hills.* La Junta, CO: Colorado Boys Ranch, 1960.

Hyde, George E. *Life of George Bent: Written from His Letters.* Edited by Savoie Lottinville. Norman: University of Oklahoma Press, 1968.

Kimball, Stanley B. *Historic Sites and Markers along the Mormon and Other Great Western Trails.* Chicago: University of Illinois Press, 1988.

Lavender, David. *Bent's Fort.* Lincoln: University of Nebraska Press, 1954.

Lewis, Hugh M. *Robidoux Chronicles: French-Indian Ethnoculture of the Trans-Mississippi West.* Victoria, BC: Trafford Publishing, 2004.

Lupton, Dorothy Ruland, and David Walker Lupton. *The Fur Trading Posts: The Rebel Years 1836–1844.* Vol. 3, *Lancaster Platt Lupton: The Legacy of a Fur Trader.* Bayboro, NC: Buckhorn Press, 2005.

———.*West Point and Beyond: The Military Years, 1825–1836.* Vol. 2, *Lancaster Platt Lupton: The Legacy of a Fur Trader.* Bayboro, NC: Buckhorn Press, 1998.

Magoffin, Susan Shelby. *Down the Santa Fe Trail and into Mexico: The Diary of Susan Shelby Magoffin, 1846–1847*. New Haven, CT: Yale University Press, 1926.

Malkoski, Paul A. *This Soldier Life: The Diaries of Romine H. Ostrander, 1863 and 1865, in Colorado Territory*. Denver: Colorado Historical Society, 2006.

Monahan, Doris. *Julesburg and Fort Sedgwick, Wicked City—Scandalous Fort*. Sterling, CO: Doris Monahan, 2009.

Parkman, Francis, Jr. *The California and Oregon Trail: Being Sketches of Prairie and Rocky Mountain Life*. New York: Thomas Y. Crowell & Co., 1901.

Patten, Jennifer. *In View of the Mountains: A History of Fort Morgan, Colorado*. N.p.: Amazon Printing, 2011.

Perkin, Robert L. *The First Hundred Years: An Informal History of Denver and the Rocky Mountain News*. Garden City, NY: Doubleday & Company, 1959.

Peters, Dewitt C. *Kit Carson's Life and Adventures: From Facts Narrated by Himself*. Hartford, CT: Dustin, Gilman & Co, 1875.

Peterson, Guy L. *Four Forts of the South Platte*. Fort Myer, VA: Council on America's Military Past, 1982.

Pike, Zebulon Montgomery. *The Expeditions of Zebulon Montgomery Pike: To Headwaters of the Mississippi River, through Louisiana Territory, and in New Spain; During the Years 1805-6-7*. Edited by Elliott Coues. New York: Francis P. Harper, 1895.

Propst, Nell Brown. *The South Platte Trail: Story of Colorado's Forgotten People*. Boulder, CO: Pruett Publishing Company, 1989.

Reyher, Ken. *Antoine Robidoux and Fort Uncompahgre*. Ouray, CO: Western Reflections Publishing, 1998.

Roe, Francis M.A. *Army Letters from an Officer's Wife*. New York: D. Appleton and Company, 1909.

Root, Frank A. *The Overland Stage to California: Personal Reminiscences and Authentic History of the Great Overland Stage Line and Pony Express from the Missouri River to the Pacific Ocean*. Topeka, KS: Crane & Co., 1901.

Sage, Rufus B. *Rocky Mountain Life; or, Startling Scenes and Perilous Adventures in the Far West During an Expedition of Three Years*. Boston, MA: Wentworth & Company, 1857.

Sides, Hampton. *Blood and Thunder: The Epic Story of Kit Carson and the Conquest of the American West*. New York: Anchor Books, 2006.

Smiley, Jerome C. *Semi-Centennial History of the State of Colorado*. Vol. 1. Chicago: The Lewis Publishing Company, 1913.

Spurr, Dick, and Wendy Spurr. *Historic Forts of Colorado*. Grand Junction, CO: Centennial Publications, 1994.

Stanley, Henry M. *My Early Travels and Adventures in America and Asia*. Vol. 1. New York: Charles Scribner's Sons, 1895.

Stegmaier, Mark J., and David H. Miller. *James F. Milligan: His Journal of Frémont's Fifth Expedition, 1853–1854; His Adventurous Life on Land and Sea*. Glendale, CA: The Arthur H. Clark Co., 1988.

Stone, Wilbur F. *History of Colorado*. Vol. 1. Chicago: S.J. Clarke Publishing, 1918.

———. *History of Colorado*. Vol. 2. Chicago: S.J. Clarke Publishing, 1918.

Thomas, Douglas B. *From Fort Massachusetts to the Rio Grande: A History of Southern Colorado and Northern New Mexico from 1850–1900*. Washington, D.C.: Thomas International, 2002.

BIBLIOGRAPHY

Ubbelohde, Carl, Maxine Benson and Duane A. Smith. *A Colorado History*. Boulder, CO: Pruett Publishing Co., 2006.

Ware, Eugene F. *The Indian War of 1864: Being a Fragment of the Early History of Kansas, Nebraska, Colorado, and Wyoming*. Topeka, KS: Crane & Company, 1911.

Werner, Fred H. *Heroic Fort Sedgwick and Julesburg: A Study in Courage*. Greeley, CO: Werner Publications, 1987.

————. *Meeker: The Story of the Meeker Massacre and Thornburgh Battle, September 29, 1879*. Greeley, CO: Werner Publications, 1985.

Whiteley, Lee. *The Cherokee Trail: Bent's Old Fort to Fort Bridger*. Boulder, CO: Johnson Printing, 1999.

Williams, Dallas. *Fort Sedgwick Colorado Territory: Hell Hole on the Platte*. Julesburg, CO: Fort Sedgwick Historical Society, 1993.

ARTICLES

Barton, John D. "Antoine Robidoux—Buckskin Entrepreneur." *The Outlaw Trail Journal* 3, no. 2 (Summer/Fall 1993): 35–44.

Block, Augusta Hauck. "Lower Boulder and St. Vrain Valley Home Guards and Fort Junction." *Colorado Magazine* 26, no. 5 (September 1930): 186–91.

Bolton, Herbert E. "Papers of Zebulon M. Pike, 1806–1807." *American Historical Review* 8, no. 4 (July 1908): 798–827.

Field, Matthew C. "Sketches of Big Timber, Bent's Fort and Milk Fort in 1839." *Colorado Magazine* 14, no. 3 (May 1937): 102–8.

Fynn, A.J. "Furs and Forts of the Rocky Mountain West." *Colorado Magazine* 8, no. 6 (November 1931): 209–22.

Gilmore, Zeralda Carter. "Pioneering on the St. Vrain." *Colorado Magazine* 38, no. 3 (July 1961): 214–23.

Hafen, LeRoy R. "Colorado Mountain Men of Fur Trade Days." *The 1951 Westerners Brand Book*. Vol. 7. Edited by Nolie Mumey. Denver, CO: Westerners/Artcraft Press, 1952: 25–47.

————. "Fort Davy Crockett, Its Fur Men and Visitors." *Colorado Magazine* 24, no. 1 (January 1952): 1–16.

————. "Fort Jackson and the Early Fur Trade on the South Platte." *Colorado Magazine* 5, no. 1 (February 1928): 9–17.

————. "The Fort Pueblo Massacre and the Punitive Expedition Against the Utes." *Colorado Magazine* 4, no. 2 (March 1927): 49–58.

————. "Fort St. Vrain." *Colorado Magazine* 24, no. 4 (October 1952): 241–54.

————. "Old Fort Lupton and Its Founder." *Colorado Magazine* 6, no. 6 (November 1929): 220–6.

————. "The W.M. Boggs Manuscript About Bent's Fort, Kit Carson, the Far West and Life Among the Indians." *Colorado Magazine* 7, no. 2 (March 1930): 45–69.

Hafen, LeRoy R., and Frank M. Young. "The Mormon Settlement at Pueblo, Colorado, During the Mexican War." *Colorado Magazine* 9, no. 4 (July 1932): 121–36.

BIBLIOGRAPHY

Hampton, H.D. "Problems of the Frontier Soldier, 1866–1883." *1963 Brand Book of the Denver Posse of the Westerners*. 19th ed. Edited by Robert B. Cormack. Morrison, Colorado: Buffalo Bull Press, 1965: 128–38.

Hill, Joseph J. "Antoine Robidoux, Kingpin in the Colorado River Fur Trade, 1824–1844." *Colorado Magazine* 7, no. 4 (July 1930): 125–32.

Kendziorski, Nik. "Civilizing Architecture: The Influence of Fort Lewis." *History La Plata* 27 (May 2011): 9.

Lambert, Julia S. "Plain Tales of the Plains." Chap. 1. *Trail* 8, no. 8 (January 1916): 5–11.

———. "Plain Tales of the Plains." Chap. 3. *Trail* 8, no. 11 (April 1916): 5–11.

———. "Plain Tales of the Plains." Chap. 4. *Trail* 8, no. 12 (May 1916): 5–13.

———. "Plain Tales of the Plains." Chap 5. *Trail* 9, no. 1 (June 1916): 16–24.

Lecompte, Janet. "Gantt's Fort and Bent's Picket Post." *Colorado Magazine* 41, no. 2 (Spring 1964): 111–25.

Nankivell, Major John H. "Fort Crawford, Colorado, 1880–1890." *Colorado Magazine* 11, no. 2 (March 1934): 54–64.

O'Rourke, Paul. "Antoine Robidoux: Notorious Trapping and Trading Entrepreneur." *Telluride Magazine* (Winter/Spring 2009–10): 42–45.

Rizzari, Francis B. "Fur Traders and Their Forts." *The Denver Westerners Brand Book*. Vol. 30. Edited by Alan J. Stewart. Boulder, CO: Johnson Publishing, 1977: 331–45.

Sanford, Albert B. "Camp Weld, Colorado." *Colorado Magazine* 11, no. 2 (March 1934): 46–50.

———. "Life at Camp Weld and Fort Lyon in 1861–62: An Extract from the Diary of Mrs. Byron N. Sanford." *Colorado Magazine* 7, no. 4 (July 1930): 132–9.

Smith, E. Willard, and LeRoy R. Hafen. "With Fur Traders in Colorado, 1839–40: The Journal of E. Willard Smith." *Colorado Magazine* 27, no. 3 (July 1950): 162–86.

Sopris, W.R. "My Grandmother, Mrs. Marcellin St. Vrain." *Colorado Magazine* 22, no. 2 (March 1945): 63–8.

Stone, Wilbur F. "Early Pueblo and the Men Who Made It." *Colorado Magazine* 6, no. 6 (November 1929): 199–210.

Taylor, Morris F. "Fort Stevens, Fort Reynolds, and the Defense of Southern Colorado." *Colorado Magazine* 49, no. 2 (Spring 1972): 143–62.

———. "Fort Wise." *Colorado Magazine* 46, no. 2 (Spring 1969): 93–119.

Thomas, Chauncey. "The Spanish Fort in Colorado, 1819." *Colorado Magazine* 14, no. 3 (May 1937): 82–5.

Thompson, Enid T. "The Ladies of Bent's Fort." *Denver Westerners Brand Book*. Vol. 30. Edited by Alan J. Stewart. Denver, CO: Westerners, 1977: 51–69.

Collections and Manuscripts

Francis W. Cragin Collection, 1890–1937. Colorado Springs Pioneer Museum.

Gilpin, William. "Governor's Message: Fellow Citizens of the Legislative Assembly of Colorado Territory, Sept. 10, 1861." Colorado State Archives.

BIBLIOGRAPHY

Gomez, Arthur. "A Royalist in Transition: Facundo Melgares, the Last Spanish Governor of New Mexico: 1818–1822." New Mexico State Record Center and Archives.

Grinnell, George B. "Bent's Old Fort and Its Builders." Kansas State Historical Society Collections. Vol. 15. 1923.

Marmor, Jason. "Historical Contexts for the Old Fort Site, Fort Collins, Colorado, 1864–2002." Prepared for the City of Fort Collins Advance Planning Department.

NEWSPAPERS

Colorado Chieftain
Daily Mining Journal
Rocky Mountain News
Weekly Commonwealth
Western Mountaineer

WEBSITES

coloradoterritory.org
fcgov.com (City of Fort Collins)
fortsandfights.com
fortwiki.com
historycolorado.org (Colorado Historical Society)
kshs.org (Kansas State Historical Society)
loc.gov (Library of Congress)
meekercolorado.com
mman.us (Mountain Men and Life in the Rocky Mountain West)
newmexicohistory.org (New Mexico Office of the State Historian)
northamericanforts.com
oldfort.fortlewis.edu
sangres.com
santafetrailresearch.com
zebulonpike.org

INDEX

ABOUT THE AUTHOR

Jolie Anderson Gallagher was raised on a farm in the Montezuma Hills of California. After earning an English/ creative writing degree from the University of California–Davis, she has worked as a newspaper reporter and a technical writer. Gallagher has lived in Colorado for twenty-five years. She is a member of the Colorado Historical Society, the Wild West History Association and the True West Historical Society. This is her second book. For more information about Gallagher's work, visit her Mile-High History blog at http://joliegallagher.wordpress.com.

Printed in the USA
CPSIA information can be obtained
at www.ICGtesting.com
LVHW062252250324
775504LV00051B/2230